MURDER & MAYHEM
—— IN ——
SCOTT COUNTY, IOWA

MURDER & MAYHEM
— IN —
SCOTT COUNTY, IOWA

JOHN BRASSARD JR.

THE
History
PRESS

Published by The History Press
Charleston, SC
www.historypress.net

First published 2018

Manufactured in the United States

ISBN 9781625859761

Library of Congress Control Number: 2017958375

Notice: The information in this book is true and complete to the best of our knowledge. It is offered without guarantee on the part of the author or The History Press. The author and The History Press disclaim all liability in connection with the use of this book.

I dedicate this book to my grandfather Robert Warren Sr., who helped to teach me about history and how to appreciate a good story.

CONTENTS

ACKNOWLEDGEMENTS

This book would not have been possible without the unyielding support of my family. I would like to thank my wife, Elaine, for listening to me whine, and my mother, Tammy, for telling me to stop whining. Thanks to my father, John, for helping me with the pictures, and special thanks to my children for just being a never-ending source of entertainment.

I would like to recognize all those who have supported my writing in a professional format by publishing my work. I thank the publisher of the *DeWitt Observer*, Larry Lough, and Bill Tubbs, publisher of the *North Scott Press*, as well as Mike Swanger, publisher of the *Iowa History Journal*.

I also recognize the support and encouragement of the local historical societies that I have had the pleasure to work with, such as the Scott County Historical Preservation Society, the Scott County Historical Society, the Central Community Historical Society and the Friends of Walnut Grove Pioneer Village. I extend special thanks to Ann Soenksen, Lois Wessels, Bob and Ramona Lee, Fred and Margaret Fedderson, Tom and Jackie Knapper, and Shirley Perry.

I also give special thanks to Richardson-Sloane Special Collections at Davenport Public Library for all of its assistance, especially with photographs.

INTRODUCTION

I t was July 4, 1845. Colonel George Davenport sat in his home on Rock Island, listening to the sounds of the night. Davenport had lived on Rock Island for over forty years, and the sounds were comfortable for him, like a pair of well-worn shoes.

Davenport's family was celebrating the Fourth of July holiday in nearby Stephenson with the rest of the city. He was feeling under the weather and did not feel like attending the festivities. Davenport did not want his family to be disappointed, however, so he insisted that they attend without him.

He leaned back in his chair and closed his eyes. Over the usual sounds of night birds and insects, Davenport could also hear the faint sounds of the parties going on in Stephenson and Davenport.

The old man laughed. He enjoyed the thought of having an entire city named after him. It had been a frontier town with big dreams, but he was sure that one day it would rank among the finest cities of the region. After all, it had his name attached to it, so it had to be great.

It had been his friend Antoine LeClaire's idea to name the town after him. He had met Antoine a few years after he had come to the area. Davenport had been a sutler at the time, a private citizen who contracted with the United States government to provide various types of supplies to the newly erected Fort Armstrong. The fort had also been built on Rock Island, so Davenport built his house a short distance away. His original home had been a double log cabin, with half of it being for living space and the other half used as a store, from which he would trade with the local Indian tribes, the Sauk and Meskwakie.

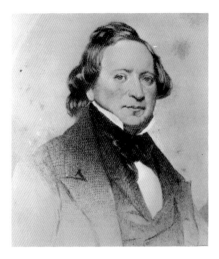

Colonel George Davenport, regional pioneer and namesake of the city of Davenport, Iowa. *Courtesy of Davenport Public Library.*

LeClaire was half French-Canadian and half Potawatomi. He had been hired as an interpreter by the fort commander in 1816 and had soon met George Davenport. They quickly became friends.

By 1818, Davenport had quit his job as a sutler in order to concentrate more on Indian trade. The natives liked him, and he soon had many different trading posts scattered across several miles. He had watched as more and more white settlers moved into the region. As they did, Davenport began to trade in furs, partnering up with a man named Russell Farnham. They soon joined the American Fur Company, further tapping into the then-thriving fur business of the early 1800s.

Davenport had become a wealthy man by this time and bought up the vast majority of local native lands that came up for sale in Illinois.

In 1832, tensions between white settlers and the Sauk came to a head when Black Hawk, one of the war leaders, took several hundred followers and traveled north along the Rock River. George Davenport quickly sent word to American forces in St. Louis that Black Hawk was aiming to start a war against the European settlers who had moved into the region. The governor of Illinois immediately sent military units to deal with Black Hawk and his followers and issued a call for volunteers to join the effort. He also personally bestowed the military rank of colonel on George Davenport. This short-lived conflict became known as the Black Hawk War.

After it ended, a treaty was signed on the western bank of the Mississippi among the Sauk, the Meskwakie and the United States government that ceded all native lands in Illinois and nearly six million acres of land on the western side of the river to the American government. Antoine LeClaire, who served as an interpreter at the signing, and his wife, Marguerite, were awarded large amounts of land as part of the treaty.

Beginning the following year, what had become known as the Black Hawk Purchase was opened for settlement. Several towns sprang up along both sides of the Mississippi, including Davenport and Stephenson.

Colonel Davenport and LeClaire invested a lot of time, effort and funds in the development of Davenport, which began to prosper very quickly. Hotels were opened, and businesses soon followed. Houses were built along the dirt streets, and more and more people began to move into the area.

Soon, the first glimmers of culture began to appear. Newspapers were founded and published, and churches of various denominations were erected. Schools were built, and the rough log cabin buildings of the frontier town were gradually replaced with more sophisticated wood frame ones, including the Colonel's own home.

All of these advancements greatly pleased Colonel George Davenport as he sat, letting the July heat warm his bones and so many memories warm his heart and soul. Wincing, he struggled out of his chair. He had sat for too long, and his body had grown stiff. The Colonel stretched and then began to move out of the room. It would do his old man's body good to walk for a bit, he thought.

Davenport opened the door to his kitchen, his eyes widening at what he saw. Although they were mere shadows in the darkened room, Davenport could see that there were strangers in his house. Before he could react, he heard a loud crack. Instantly, a pain like white-hot fire blazed in his leg. With a cry, he grabbed his leg, lost his balance and fell. Davenport let out a groan

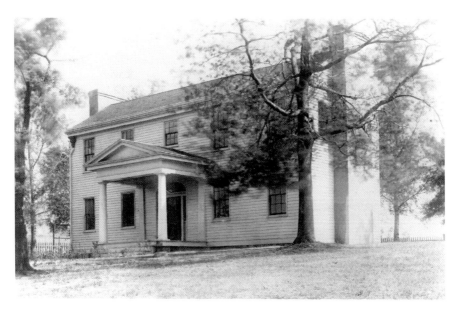

The Davenport home on Rock Island, Illinois, now Arsenal Island. *Courtesy of Davenport Public Library.*

as he slammed into the floor. Quickly, the strangers were upon him. They roughly grabbed him and bound his hands and feet with lengths of rope.

Their questioning started immediately. Through the pain and surprise, Davenport began to assess the situation. They wanted money. He heard one of them mention $20,000, but he did not quite understand.

The men dragged the wounded Colonel to his safe and demanded that he open it. He did as he was told. Davenport's captors eagerly looked on as one of their number reached in and took out $400. To Davenport's surprise, the men grew angry. They demanded to know where the rest of the money was, but he insisted that was all that was in the house.

The robbers became violent as they grabbed the helpless Colonel and took him into his bedroom. There, they mercilessly beat the old man within an inch of his life. When their rage was spent, they took the money and left the house, leaving Colonel Davenport moaning in pain. With the last strength that he had left, he began to call out for help.

Luckily for him, some men happened by the Davenport home about that time on their way to fish. They heard his pitiful cries and went immediately to investigate. They found the Colonel inside, badly hurt and nearly incoherent. One of them, thinking quickly, ran to get a doctor and any other help that he could find.

Upon hearing the news, many gathered to find the bandits who had committed this horrible crime, while a local doctor went to tend to Colonel Davenport. The doctor could do little more than ease the old man's suffering and listen to him as he related what had happened. Soon after, George Davenport, the frontier pioneer and wealthy businessman, passed away.

The bandits themselves were quickly rounded up and brought to justice. It was discovered that the men had heard that the wealthy Colonel kept nearly $20,000 in his safe. They decided to take advantage of the holiday, sure that the Davenport family would be at the Fourth of July celebrations with everyone else.

When they entered the home and the old man walked in on them, they had been just as surprised as he. One of them shot him almost more from being startled than from malice. They had not planned on killing Davenport, but $20,000 was a lot of money and, in their minds, had more than justified their actions at the time.

Out of the bandits, one spent life in prison, while another escaped captivity and fled, never to be heard from again. All of the others were hanged.

Davenport was buried near his home on Rock Island. The city that had been named after him continued to grow. The seeds of greatness that he

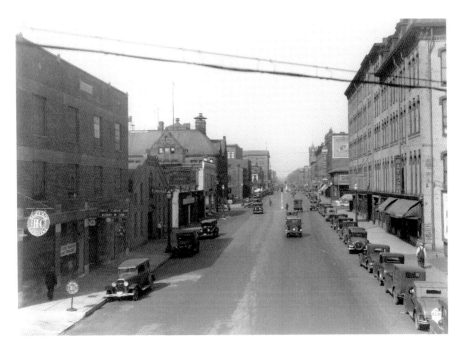

Downtown Davenport in the early twentieth century. *Courtesy of Davenport Public Library.*

had helped to sow began to bear rich fruit. Businesses and factories were built, with railroads and riverboats helping them to flourish. Art, music and entertainment came, too, as well as mercantile stores selling various goods.

The territory that Colonel Davenport had known became the state of Iowa the year after his death. It was split into several counties, and the region that he had known on the western bank of the Mississippi became Scott County. Like the Colonel's namesake city, the county also began to flourish. Towns like Long Grove, Eldridge and LeClaire sprang up and prospered. Farmers began to till the land and became wealthy off the crops that grew.

But underneath the shiny veneer of progress and prosperity, darkness lurked. Like the dim shapes that Colonel Davenport saw in his house that long-ago night, grim deeds and dark desires swam just underneath the surface of Scott County's successful façade.

Even the electric lights of the twentieth century could not dispel the darkness. Organized crime and prostitution thrived in places like Davenport's notorious Bucktown area, as well as bootleg liquor sales during the Prohibition era. And hidden in homes and businesses, behind closed doors and in dim corners, even fouler things thrived.

INTRODUCTION

In these next chapters, you, the reader, will be exposed to some of this darkness. Tales of madness, abuse and murder will show you the ugly underbelly that has, from time to time, served as a counterbalance to the wonderful success and accomplishments of the county that they took place in. As you will soon see, sometimes a beautiful place like Scott County has experienced truly ugly events.

A MATCH MADE IN HELL

I t was spring in Pleasant Valley, Iowa. Spring is always a special time of year. Asleep after a long winter slumber, the various flora and fauna were starting to turn green again with new life. Flowers began to bloom again in a vivid array of colors, splashing blues, whites, purples, oranges and reds across a rich backdrop of greens and browns. Farmers were busy in their fields, plowing through the rich black soil in order to make way for the annual planting.

The township of Pleasant Valley had been following this same pattern since the first settlers had come there in 1833. Drawn by the natural beauty of the area, these early pioneers had not only begun to transform the grassy fields there into successful farms but also began to build some of the rudimentary hallmarks of industry. A sawmill was constructed in order to process some of the abundant timber into useable lumber for building. Valley City was founded, and with its birth, some more of the basic benefits of civilization, such as mail service, came into being for the rural residents of the township.

It was into this rural farming community that a man named Reinhart Hose settled.

Born in 1839 in Hessen, Germany, Reinhart immigrated to the United States in the late 1860s, eventually coming to Iowa. He bought a farm, married and settled into the life of a farmer. Eventually, Reinhart and his wife, Elise, had a daughter, whom they named Mary.

Mary was raised in the farming community of Pleasant Valley Township, where she was relatively well known and, more importantly, very well liked. Reinhart could not have been prouder of her. As his only child, he and Elise lavished all of their love and affection on her.

In about 1889, Reinhart took a trip to Washington, D.C., to visit a friend named Schultz. Schultz was working as a clerk in the Treasury Department there. The two men had attended school together in Germany before immigrating to the United States. They were anxious to see each other again and catch up on the events that had transpired in their lives since they had last seen each other.

Schultz and his wife were gracious hosts and treated Reinhart extremely well. During the many conversations that they had during his visit, many subjects were probably discussed. They probably talked about where they had settled and built their lives and about their families. Reinhart talked about Mary, his pride and joy, and got to meet Schultz's own family.

Schultz had a son named Henry, with whom Reinhart became very friendly. Reinhart really liked the young man, who worked as a plumber in the area. He told Henry about Mary and talked about how much she would have liked to come with him. Mary was in her late teens around this time, and like many parents meeting others whom they consider to be solid dating material for their children, Reinhart began to pave the way for young Henry to begin writing to Mary.

Reinhart returned home a short while later, telling Elise and Mary all about his old friend in Washington, D.C., and his family. And, of course, he made sure to tell Mary about that wonderful Schultz boy. Soon, Henry and Mary began sending letters back and forth.

But while Reinhart was probably hoping for love to bloom between the two young people, Mary had other plans. She had just finished school and was hoping to further her studies at college. She had found a suitable women's school in Chicago and wanted to attend. Mary told her parents about the idea, and they agreed to pay for her continuing education. While it more than likely made them sad to see her go, she was their beloved only daughter, and they would do anything for her.

Mary was accepted to the school, and Reinhart and Elise saw her off. For the next few years, Mary dedicated herself to her studies. Through that time, she and Henry Schultz maintained a friendly correspondence.

Eventually, Mary graduated and returned home to Pleasant Valley, Iowa. She had always been considered attractive and popular, and the locals there whom she had grown up around were excited to see her. They welcomed her

home with open arms, and Mary happily greeted them in return. One of those who was present to welcome her back from Chicago was none other than Henry Schultz.

He had come from Washington, D.C., to finally meet her face to face. One thing led to another, and Henry proposed marriage to Mary. She accepted, much to the excitement of her parents. But no matter how much she may have tried, Mary always came off as being no more than lukewarm to the thought of marrying Henry. Perhaps she saw how happy the idea made her father, or maybe she had decided that it was time for her to get married and have children, and Henry just seemed like a viable choice.

Henry did have his good qualities. He had a solid, professional job as a plumber. He was a dedicated churchgoer, and he did not drink alcohol. Mary may not have ever seen him face to face before that time, but they had been talking through mail correspondence for a few years now. Besides that, her father and his father were good friends, and her dad was very impressed with the young plumber. So why not marry him?

And so it came to be that during the fine spring season, as flowers bloomed and long grass waved lazily in broad green fields, twenty-year-old Mary Hose waited to marry Henry Schultz. Perhaps, as she walked down the aisle toward her awaiting groom, those lukewarm feelings that she had about the marriage began to ease somewhat. In the excitement of the day, maybe her anxieties simply melted away and she was able to imagine a new life with Henry. She should have trusted her instincts.

After they were married, Mary had hoped to settle back into life in Pleasant Valley. After so many wonderful childhood memories there, it must have seemed natural to Mary to want to go home again. But her new husband had other ideas. He wanted to return to Washington, D.C., and his plumbing business there. Mary relented, and the two made plans to settle in the nation's capital.

Before they left, Reinhart gave his daughter $500, telling her that it was a wedding present. Kissing his beloved daughter goodbye, he shook his new son-in-law's hand, wished him luck and sent the brand-new couple on their way back east.

Soon after their arrival in Washington, the first cracks began to form in the marriage. During his visit to Iowa, Henry must have been on his absolute best behavior and had tried to make a wonderful impression on Mary and her family. During conversations with them, Henry told them that he was a regular churchgoer. He understood the standard German drinking customs, but he stated that he did not drink. Mary quickly discovered that he had lied.

Henry drank heavily, anything from beer to hard liquor. The $500 wedding present quickly dwindled away.

Mary, as she had done since attending college in Chicago, wrote frequently to her parents in Iowa. Her growing dissatisfaction became more and more apparent in her letters. Reinhart and Elise started to worry and soon wanted to have their daughter back home with them, where they could keep a close eye on her. Discussing it between themselves and then making their own plans, they wrote to Mary and Henry, proposing a new idea.

Reinhart and Elise told them that they should come back to Iowa and take an interest in the Hose farm in Pleasant Valley. Mary and Henry could live with them while the younger couple took over the daily operation of the farm. By paying a very generous low rent and running what was already a successful farm operation, Henry could set himself and his new wife on a very lucrative path. It did not take long for them to move back from Washington to Pleasant Valley.

Henry and Mary moved onto the farm and immediately set to work. Almost as immediately, Reinhart and Elise realized, just as their daughter had, that Henry had lied to them. Henry showed a genuine taste for whiskey, and he drank all the time. The abuse was almost constant. Henry would frequently berate his wife, swearing at her and calling her names.

In spite of all this, Mary bore her husband a son the year after they were married. For some men, this may have softened their disposition and caused them to rethink their lives. Men like that might even make a change for the better. Henry was not one of those men.

Only two days after the child was born, Henry professed his desire to choke the infant to death with his bare hands. Later that same day, Mary asked Henry to close a window in their bedroom, where she was lying sick in bed. The wind coming from outside was making her cold. Henry, being the attentive husband that he was, stalwartly refused and left Mary to her own devices. Another time, Henry found that his infant son had moved off the blanket he was lying on. He lambasted Mary for it, and she told her husband that the baby was always moving off the blanket. Henry picked up his son and began to tell him how his mother did not love him and would be just as happy if he were dead.

Eventually, a second son was born, with Henry showing the same fatherly affection toward him as he did his firstborn. When the boys would irritate him, Henry was known to drag them to the barn, where he would take them to a cow stall, tie them up and leave them. Suffice it to say, the boys were terrified of their father.

In spite of his seeming disdain for his own children, Henry was not above using the boys as a way to further insult and terrify his wife. One morning, before they had even gotten out of bed, Henry began to berate Mary, cursing at her and calling her every insulting name that he could probably think of. As if this was not bad enough, Henry told her that he was going to teach their oldest son to kill his grandparents if they ever dared to raise a hand or use a word to correct him.

Henry's abuse was not limited to Mary and the children. One morning, Henry and Mary were preparing to go to nearby LeClaire, Iowa. While Mary was speaking to Elise, Henry approached and asked Mary if he had any underwear. Mary was not sure and had to take a few seconds to think about her answer. Before she could speak, Henry called her an idiot. Elise tried to intervene, gently telling Henry that he should be more patient and give Mary a little time to think about her answer. Henry, in reply, began cursing at Elise.

More than once, while fighting with Mary over one thing or another, Henry would exclaim to the household that he was just going to go kill himself. Taking a pistol that he owned, he would stride purposefully out into the farmyard and fire a shot into the air. As soon as he did, he would fall onto the ground and lay still, pretending that he had actually shot himself.

Henry ran the farm for six years. During that entire time, he continually abused his wife, children and in-laws. Neither they nor their neighbors were absolutely sure what he did with the money he made on the farm, but there is room for speculation. Henry frequently drank, buying the best booze he could find. He explained to one neighbor that he had not moved all the way to Pleasant Valley from Washington, D.C., to settle for second best.

In spite of the fact that Henry ran the farm for Reinhart and Elise, Reinhart made sure that he held the title to the property. Several times over the years that they lived together, Henry tried to get Reinhart to sign the farm deed over to him. But the old German farmer stalwartly refused and stubbornly held onto the title with the tenacity of a starving dog defending a scrap of meat.

Once, during those six long years, Mary left Henry. After they were first married, Henry, in one of his angry ravings, told Mary that he was going to kill her beloved father, Reinhart. She could not bear him anymore and fled to the home of John Dodds, a trusted neighbor who lived just down the road from the Hose farm. She had just entered their front door when Henry burst in almost right behind her. He pleaded with her to return, explaining to Mary and the Doddses that he was only joking and that there

was no truth to his words. Mary chose to believe him and returned to the farm with him.

Over the years, Reinhart and Elise had also moved off the farm, hoping that Henry and Mary would be able to work things out if they were no longer living there. For his own reasons, Henry always lured them back.

In the spring of 1897, Mary left Henry for a second time, staying with neighbors for several days until Henry finally succeeded in gaining enough of her trust to bring her back home. But, just as it had happened before, the abuse started again.

Henry was a tyrant, ruling the farm with an iron hand. His anger and hatred spewed forth from him in an unending tide, drowning his wife, his children and his in-laws in its vile black flood. For six long years, Mary endured. But six years is a long time for anyone in that kind of situation, and in 1898, things finally came to a head.

One night, Henry returned to the farm after everyone had fallen asleep. Drunk, he walked through the door, a jug of whiskey in his hand. On the kitchen table he found some butter rolls that Mary had baked that were to be taken to LeClaire the following day. Staring at them in his drunken haze, Henry decided that something about them was not right. Hot-tempered man that he was, Henry immediately lost what little self-control he possessed.

He stomped up the stairs and into their bedroom, where Mary lay sound asleep. He roughly awakened her. Her mind had just climbed into the first vestiges of consciousness when Mary found herself pulled out of bed and herded down the stairs. Henry took her to the kitchen, where he demanded that she remake the rolls until they suited his tempestuous fancy.

The next day, Henry hitched the horse to his buggy, loaded the rolls and his oldest son into it and started for LeClaire. Once some time had passed and Mary was sure that he was gone, she hastily packed some belongings, took her youngest son and went directly to the house of Guy LaGrange.

LaGrange was a schoolteacher in nearby Valley City, but he was also the son-in-law of John Dodds. Dodds and his wife had recently moved to Davenport, in the neighborhood of Brady Street and Kirkwood Boulevard. Mary pleaded with LaGrange to take her and her son to the home of his father-in-law. Well aware of Mary's domestic situation, LaGrange readily agreed and took her to Davenport.

Once there, Mary once again asked her old friends to shelter her from Henry. She explained that she had left Henry and taken their youngest son with her. Mary was determined that this time it would be permanent. Like

LaGrange and many of their other Pleasant Valley neighbors, the Doddses knew what Henry had been doing and were more than happy to help.

During the next few days, Mary visited the law firm of Heinz and Fisher to file a petition for divorce. She sat down with the lawyer and related the entire tale of her unhappy marriage, including the years of abuse she had suffered at the hands of her drunken husband. The petition was written and filed. As before, Henry discovered where she was staying and came to Davenport in an attempt to bring her back to Pleasant Valley. But this time she would not come home to him, no matter how much he pleaded or how charming he tried to be.

Realizing that she was serious this time, Henry quickly retained his own lawyer at a different firm, Lischer and Bawden. Henry told Lischer that he did not want a divorce but, rather, just wanted his wife to come home. The second time he met with the lawyer, Henry stated that he had been to see Mary a few times on his own. He asked if he should keep trying to visit her. Lischer responded with a resounding no. He explained to Henry that it was entirely possible that things might be reconciled between them while waiting for their court date. Henry promised his lawyer that he would not try to see Mary again and left the office. Unbeknownst to anyone else, Henry had already begun to form plans of his own.

Entering a local gun store owned and operated by a man named Berg, Henry traded a shotgun that he owned for a new .38 Smith and Wesson revolver. While talking with Berg, Henry decided to tell him that the pistol was for killing livestock. Henry claimed that his neighbors in Pleasant Valley would often ask him to shoot their cattle for them and that he had developed a particular methodology in the performance of the task

Henry said that he would have a cob of corn in one hand, and in the other he would secret his pistol. He would be friendly to the animal, luring it in with the food. The condemned animal would eventually come over and begin to eat. Henry would bide his time, waiting for his victim to fully relax. Once he felt the animal had reached that point, he would put his gun within close range and pull the trigger, fulfilling his task. To further illustrate his point for all those present in the gun store, Henry pantomimed his killing methodology as he described the various steps involved.

But Henry's plans for his new revolver did not involve livestock.

As a matter of fact, Henry was quickly finalizing his plans. He had weighed out his options, considered his choices and consequences and, finally, had come to a very definite conclusion as to what he should do. It was time for Mary and him to die. But first, he had to explain himself.

Henry was human, and even as abusive and alcoholic as he was, he felt compelled to tell his side of the story.

So Henry sat down and began to write a series of four very long letters. He must have wanted to get things correct, to fully explain how he felt. One letter went to his own parents back in Washington, D.C., and another he wrote for the benefit of Reinhart and Elise. He knew that the actions he was about to undertake would draw a lot of attention, so he wrote still another letter to the *Davenport Democrat and Leader*, one of the most prominent newspapers in the region, so that it could share his feelings with the world.

His fourth and final letter he wrote to his friend Emil Wiese. In it, Henry expressed his feelings over the situation that he now found himself in and how he felt like he was being crushed by this tremendous pressure. Henry asked Emil if the man would be kind enough to see to it that he was buried by Mary's side. He ended the letter by asking his friend to kiss his sons and to help cheer them up. And with those final words written, Henry was satisfied. It was time to act.

Jesse Dodds and his wife lived on Brady Street, just north of Kirkwood Boulevard. Their property had a decent-sized yard with a barn. By Saturday, August 6, 1898, Mary had been staying there for about a week. She was probably feeling a little more confident, relaxed and safe than she had for a long time. She did not have to face the daily insults from her husband that had become all too commonplace. Life must have started to seem just a little sweeter than it had since her marriage. Perhaps if Mary had known how sour everything was about to go for her that morning, she would have gotten as far away from Davenport and Henry Schultz as she possibly could.

As Mr. and Mrs. Dodds and Mary went about their daily activities, Henry Schultz and his elder son drove up nearby Main Street, bringing his buggy to a stop near Seventeenth Street. At that point, an alleyway ran behind the Doddses' residence and made an ideal way to get onto the property without being seen. Getting out of the buggy, Henry hitched his horse and began to walk down the alley to the Doddses' barn. His son was left unattended in the buggy to entertain himself.

Gradually, the house came into view. Mary was there in the yard, washing clothes. Mr. and Mrs. Dodds, their daughter and Henry's three-year-old son were also there, but Henry paid them little heed. The pistol that he had secreted away in his pocket was meant for Mary, not for them.

Henry thought back to when he had been there before, when he had tried in vain to coax his wife out of the house. Mary had been stubborn. She was adamant about the divorce and would not come out. The house was

Henry Schultz parked his buggy in this area, at Seventeenth Street, on his way to murder his wife. *Author's collection.*

obviously her refuge, and if Mary were to see him in the alley, then she might get scared and retreat inside its stout walls. Once inside, Henry might never have the opportunity to kill her.

Like a mountain lion stalking its prey, Henry walked carefully around to the front of the house so that Mary would not see him. From there, he came into the backyard where his wife was and placed himself between her and the back door, cutting off her avenue of escape into the house. Probably using the same suave charm that he had used in the past, Henry greeted those in the yard. He kissed his son, and Mary allowed him a kiss after that.

Ignoring the Dodds family for the most part, Henry began to talk to Mary in German. He began his old diatribe again, telling her that he wanted her to come back home. But Mary was still adamant. Being away from him had only strengthened her inner resolve, and she absolutely refused to return to Pleasant Valley with him.

In the hidden places of Henry's mind, where he hid his murderous intent, Mary's words probably only served to reinforce his decision to end her life. Changing tactics, he asked her if she would come into the barn with him to see her elder son. Mary resisted at first, but her desire to see the child she had left behind proved too strong, and she agreed to Henry's request. The Doddses did not speak German and understood little of the transaction.

Mary was wary of Henry, having been on the receiving end of his abuses for the better part of a decade. She asked her friend and protector Jesse Dodds to come with them inside the barn. Jesse, who had so graciously opened his home to Mary and her son, readily obeyed. This was his home, and he would entertain none of Henry's nonsense there.

Once inside, Jesse began to tend to his horses in order to give Mary privacy with her husband. The three-year-old had come with his parents, and his father asked the boy to fetch his brother, telling him the location of the buggy. The boy ran out the back of the barn and into the alley, looking for his sibling.

As the estranged couple continued to converse, they noticed that the young boy had not returned. They thought that, in the manner of many three-year-olds, he was probably not only having trouble finding his way but also probably getting distracted by all kinds of other things.

Turning to Dodds, Henry, speaking English now, asked the man to go check on his son. Jesse was not about to leave Mary alone with Henry or be ordered about by a man he probably did not care for. Ignoring Henry, Jesse asked Mary if she would like him to go and see what the young boy was doing. Mary said that she would, and Jesse set off down the alley in search of the young boy.

Henry watched Dodds leave. He kept talking to his wife, keeping her distracted in the same way that he would an animal he was about to kill. Instead of an ear of corn, he was using his words to lure her into relaxing her guard. He was also giving Dodds as much time as possible to get to Main Street, where it would be too late for him to help. As he continued his conversation with Mary, Henry's hand began to slide into his pocket and around the grip of his revolver.

Meanwhile, Dodd had reached the end of the alley. He looked over to see the two brothers running toward him. The younger boy had completed his task after all, and now his older brother was running toward the house, excited to see his mother. Dodds smiled then at the two boys, who had experienced so much misery at the hands of their father and yet still held onto the innocence of youth. But when he heard the first gunshot echo from his house, the smile quickly disappeared from his face.

In the barn, Henry was finally satisfied that Dodds was well and far away. All of his preparations over the past week had come to a head in that moment, and he finally had his unprotected wife alone. With a snarl, he drew the revolver and fired, point blank, at Mary.

Her eyes widened in surprise as she first saw the gun and then a flash of light from the muzzle. Immediately, she felt one of the weapon's deadly projectiles tear a path through her torso. Instinctively, she turned and began to run.

Mary left the barn and went into the yard. Her chest was burning from the wound in her torso, now bleeding freely. Her mind was screaming at her to run, to escape. But Henry was right behind her, murder in his heart and hate in his eyes. Running toward Mary, he raised his revolver and fired again.

Dodds was sprinting now. He knew that it had been a mistake to leave Mary alone with Henry Schultz. How many times had Henry done the same thing? Abuse his wife, tie his children in a cow stall and when they left him, turn on the charm and lure them back? But this time, Henry did not want to bring his wife back—he sought to put her in the cold, hard ground.

Dodds knew Henry had a gun now and knew that he would need something to fight with. He saw a few rocks lying on the ground. They were of a good size and might be heavy enough to do some damage. Pausing for a precious few seconds, Jesse Dodds leaned over, picked them up and began running again.

He heard another shot and then another. He pushed down his fear for Mary, steeled himself and struggled to run even faster.

Henry had missed his second shot. Mary kept moving, trying to get inside the house. The door had become her entire world now, and all of her focus and will was bent on reaching it. The gunshot in her chest was burning worse now, sending waves of pain coursing through her body. Still she pressed forward. Mary was just a few feet away now, the knob almost within her grasp.

But Henry was moving, too. Spurred on by his negative emotions and unhampered by any injuries, he was able to move faster than his wife. As she neared the door, Henry grabbed her roughly in one hand and brought the gun close to her body.

Wounded though she was, Mary began to struggle and fight Henry with all of her remaining strength. Her will to survive was strong, and she was determined to escape. Henry pulled the trigger and shot her again, the muzzle of the gun so close that the discharge of the firearm burned Mary's skin around the wound.

But still Mary struggled on, clinging to life. Henry held fast, determined to see his grim task through. He raised the gun to his wife's right temple and fired again. With a roar, the bullet left the gun, entered Mary's head and

passed out through her left ear. She stopped struggling; the life that she had fought so hard to preserve was now leaving her body. Slowly, Henry released his grip and let Mary fall to the ground.

He took a deep breath and then exhaled. His task was done. Mary was dead. There was one last thing to do. Henry started walking across the yard, steeling himself for this final task. He stopped and raised the revolver to the side of his head. Henry pulled the trigger one last time, sending a bullet through his own brain, killing himself almost instantly.

Dodds ran into the yard, ready to fight in defense of his friend. What greeted him was only stillness. Panting, he scanned the area, looking for Henry. Dodds saw them both then, lying on the ground. Henry was dead, killed by his own hand. But Mary, almost miraculously, was not. She was still alive! As fast as he could move her and still be gentle, Dodds picked up the gravely injured young woman and carried her into the house.

Outside, the neighborhood was buzzing with worry and excitement. The neighbors had heard the gunshots and were anxious to know what had happened. W.L. Allen, a local doctor, had been traveling down Kirkwood Boulevard when he heard all the commotion. He was immediately concerned and turned his buggy toward the sounds. He arrived at the Dodds home shortly thereafter. Allen found Mrs. Dodds in the front yard and quickly

The home where Mary Schultz was murdered was located along this stretch of Brady Street in Davenport. *Author's collection.*

checked to make sure that she was okay. Satisfied that she was, the doctor proceeded around the house to the backyard, where he discovered what had happened. Allen checked Henry's body and knew he was already dead.

He went into the home, where he found Mary. To his disappointment, Allen discovered that he was already too late to help the long-suffering Mary. Once inside, Mary, a fighter to the bitter end, had finally succumbed to her injuries.

Others quickly followed Allen to the scene of the horrible murders. Another doctor who lived just a short distance away showed up, as well as an ambulance and some policemen. Unfortunately, there was little help that they could render other than to comfort the living and collect the dead.

Mary and Henry were taken to a local undertaker, and a coroner's inquest was held a short time later. The verdict of what had happened was no surprise to anyone; it was obvious Henry had murdered his wife and then committed suicide.

The letters that had been sent out by Henry before his death were opened. They were long, rambling diatribes on how his in-laws had slighted him and how the majority of what had happened was their fault. While it was Henry's wish that he be buried next to Mary, the families were not going to allow that to happen.

After the inquest was over, Henry's body was sent back east to Washington, D.C., to be received by his family there. Mary, however, was taken back to her home in Pleasant Valley. News of her murder had spread like wildfire; while there were few who cared for Henry Schultz, Mary was almost universally loved.

During the funeral, several people from all over the area came to give Mary Schultz their final respects. Her funeral had the largest attendance of any in that area up to that time. After the services, Mary was taken to the Pleasant Valley cemetery and buried, far from the abusive husband who had so cruelly taken her life.

The two boys, now orphaned, were taken in by Reinhart and Elise. They were loved and raised by their grandparents, who gave them all the affection they could ever have. The two orphans grew up in a loving home, eternally free from the abuses of their father.

OBSESSION

In rural Scott County a few miles north of Bettendorf, Iowa, a white wood-framed building has stood for over a century. It has weathered storms and blizzards and has seen the county and the land grow and change. It has withstood the tests of time and, in some ways, become part of the very landscape itself.

But not all the events that it has borne witness to have been good. On a fall evening in 1906, it played a central part in a horrible tale that resulted in the untimely deaths of two people. That story begins with a man named John Drenter.

John Drenter was born in Germany. Like so many of his countrymen, he made the decision to seek better opportunities in the United States. In the 1840s, Drenter and his wife, Mary Jane, left their home in Bremen and settled in Pennsylvania. Eventually, they moved west again. They settled in Scott County, Iowa, along Territorial Road northeast of the city of Davenport. Satisfied with what they had there, the young couple settled in and began to grow firm roots.

They bought land and built a successful farm. The couple mingled in the community, forming bonds and friendships. Their children learned about the various ways of farm life. And, like many people in that area, they attended services at the Presbyterian Church of Summit on nearby Utica Ridge Road. The Summit Church, as it was more commonly known, had come into being because of the condition of rural roads.

Roads are largely taken for granted in the modern world. People drive to and from work and take trips all the way across the nation. They drive three hours across the state to see relatives or friends. If an individual is so inclined and the geography is favorable, they can even drive into another country. But in the early days of Scott County, roads were hard and the way long.

In the early to mid-nineteenth century, horses were the kings of the road. A person could ride on horseback or take a buggy, wagon or stagecoach pulled by two or more horses. If they did not want to handle a horse, then they walked. Travel in this manner could take hours or even days for a person to reach his destination. The problem, however, was not the method of transport so much as what a person had to travel along.

Road conditions were a heavy factor in travel during the nineteenth century and even up into the early part of the twentieth century. During certain times of the year, or just after a good rain, roads often turned into almost impassable morasses of mud. Wagons and buggies could become stuck up to their wheel hubs and require help to become free. Enterprising farmers or young men would sometimes capitalize on this fact by traveling the muddy roads and removing travelers from their predicaments—for a small fee, of course.

When the roads dried out, they could become extremely bumpy and warped. In the summer months, they could be dusty, and strong winds would

John Drenter settled along Territorial Road, pictured here, when he came to Scott County. *Author's collection.*

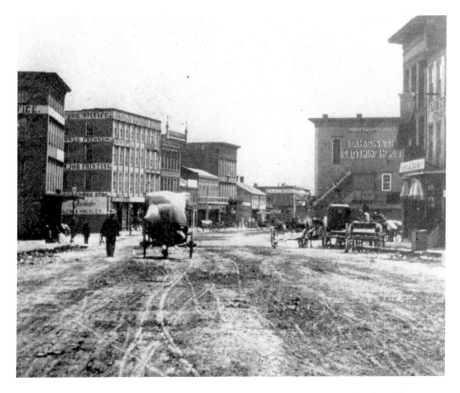

Dirt roads like this one in Rock Island, Illinois, were the order of the day in the early twentieth century. *Courtesy of Davenport Public Library.*

blow loose dirt into the faces of travelers. Unless an individual was traveling inside a stagecoach or some other kind of enclosed conveyance, people were very much at the mercy of the blinding dust.

In winter, bitterly cold temperatures and howling winds across the open fields made traveling in an open buggy not only uncomfortable but also extremely dangerous. Deep and drifting snows could also block the roadways, making them impassable in some areas until the temperatures warmed and melted the clogged roadways.

Bad roads and limited travel in certain times of the year were simply a fact of life in rural areas. As people had for centuries before, individuals who lived in the country would store enough crops and meat to get through the winter. Farmers would sell off the surplus of the various crops that they grew. For tools and equipment, they could stockpile a certain amount of parts or pieces. If he was capable, an individual could even manufacture the needed part himself. But even for self-reliant rural folk, there were still some

things that either could not be done on the farm or they felt uncomfortable doing themselves. One of these things was religion.

Presbyterian settlers had established themselves in that region in an area that became known as Churchhill's Settlement. Mostly from Pennsylvania, many of them had become farmers and were of a religious mindset. Unfortunately for them, the nearest church was in Davenport to the south, the First Presbyterian Church. First Presbyterian was located on Third Street at that time, which was only a short distance from the Mississippi River. This necessitated a round trip of several miles every Sunday, and that was only if the roads were clear enough and the weather was permitting of the trip. Regardless, there were several farmers from Churchhill's Settlement who made this sometimes uncomfortable trek as often as they could. But as dedicated as they were, the round trip eventually began to wear very, very thin on their patience. Soon enough, they decided to do something about it.

In rural areas, it was often the habit of individuals to petition a clergyman of their particular denomination to make the trip out to a home or public building in their town or area and hold services for them once or twice every month. For the residents of Churchhill's Settlement, they reached out to James Dinsmore Mason, the resident minister at First Presbyterian Church in Davenport.

Like them, J.D. Mason was from Pennsylvania, having been born there in 1812. When he was a young child, he joined a local Presbyterian church and almost immediately liked it. He was hooked. As he grew older and became an adult, Mason decided to pursue a Presbyterian education in the hopes of becoming a minister. Those hopes were realized in 1841, when he completed his studies and earned his preaching license. About two years later, Mason was officially ordained to the Presbyterian ministry.

When James turned thirty years old, he married Anna S. Blaine, with whom he would have six children and stay for the rest of his life.

In 1847, Mason traveled to Iowa for the first time. During the few months that he spent there, he fell in love with the potential that the newly forged state held. So, after his temporary stay, he traveled back to Pennsylvania, gathered his young family and began preparations to make a permanent return to Iowa.

In the spring of 1848, Mason and his family traveled west and settled in Lee County, Iowa, in the vicinity of Fort Madison. He was very successful in his spiritual endeavors, and with that success, his reputation grew. By September of the following year, he had been approached by the

First Presbyterian Church in Davenport to become its resident minister. Mason happily agreed to accept the position and moved his family north to Davenport.

When he arrived, Mason had a congregation of thirty-three members at his new church home. But he was a man of will and vision. Channeling the pioneer spirit that was so prevalent within the then frontier state of Iowa, Mason worked exceptionally hard over the next ten years to spread the Presbyterian faith and grow that small thirty-three-member congregation.

In addition to his ever-vigilant endeavors within First Presbyterian Church, Mason always kept an eye outside of his own church and into the rural areas around Davenport. His was a true missionary mentality, and a short time after his arrival, he began to travel to a church in nearby LeClaire, Iowa. It did not have a minister in residence, so for the next year and a half, he would gather some belongings and his Bible and trek out to LeClaire once a month. Eventually, LeClaire gained a minister of its own, and Mason turned his attention to other rural areas within the confines of Scott County.

He soon began to travel to the western edges of the county in order to preach to the fine people of Bluegrass, Iowa. Eventually, he would found new churches not only there but also in nearby Walcott and Eldridge.

By 1857, the congregation of First Presbyterian had grown to around two hundred members and included such prominent early Davenport pioneers as J.M.D. Burrows, who at one time was considered to be the wealthiest man in the city. It was about this time that the farmers in and around Churchhill's Settlement north of town approached Mason about traveling to their area.

Mason had just been released from other travel obligations, and he readily agreed to travel to the settlement once or twice a month. Soon, the missionary preacher started out to spread the word down the lonely and dusty roads of rural Iowa once again.

By 1858, some of the church families, along with J.D. Mason, decided that they should build a permanent church in the area. Alfred Churchhill, for whom the settlement had been named, donated five acres of land for the project. Another member, Charles Kinkaid, donated funds toward the actual material costs of the project, such as lumber. By mid-February 1859, the church had been built and organized as the Presbyterian Church of Summit.

It was a modest-sized, wood-framed building. Tall, rectangular windows ran along the north and south sides of the building, filled with marbled stained glass. These could be opened to cool the building during

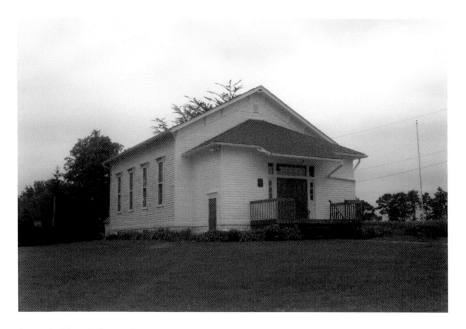

Summit Church, located along Utica Ridge Road in rural Scott County. *Author's collection.*

the heat of the summer, and a coal furnace heated the building during the winter months.

By the time the last window was placed and the final nail driven in, the church had cost about $1,200. Twenty-eight members of the brand-new church received official letters from Presbyterian Church leadership that identified them as founding members of Summit Church. Behind the scenes, Mason was wrestling with a tough decision about his future.

Mason had grown a flourishing congregation at First Presbyterian and had further gone on to found several other regional Presbyterian churches. To his mind, his services were no longer required in the city of Davenport or any other church he had founded. All except one, that is. To everyone's surprise, J.D. Mason quit his position with the First Presbyterian Church and accepted the honor of being the very first resident minister at Summit Church.

But Mason was always a little on the restless side. He was always looking to move out to the frontier and use his God-given talents to preach and grow congregations more toward the outskirts of civilization. In October 1859, he left Summit Church to the care of another minister and set out to where he felt needed.

Summit continued to thrive and grow. Although it was only locals who attended services there for the most part, they were steady and consistent. With church only a few miles away, individuals in the region could attend services almost year round, with exceptions only being taken for the absolute worst of weather conditions.

Over the years, Summit thrived, and so did the world around it. Davenport continued to grow, as did the towns of Eldridge and LeClaire. More people began to settle in the region, and the established families grew and prospered.

John and Mary Jane Drenter had done well since settling near Territorial Road in Scott County. Their eldest son, Ora, was born in 1862 and started attending services with his family from the very beginning of his life. As other children were born, John brought them to services as well, ending with his youngest son, Harrison. The brothers learned the farming trade from their father and became quite skilled as they grew older and stronger.

While attending services at Summit, Ora met a young woman named Nellie McDowell. She played the organ there and was also known around the farm neighborhood to be an excellent seamstress. One day, they caught each other's eyes and started courting. In 1894, Ora and Nellie married and settled into a secure life in the area where they had grown up. Eventually, they owned a very successful farm and had four healthy children. Harry, Ora's younger brother, was still single and lived with them.

By 1900, Ora had a good wife, happy children and a capable brother to help him on the farm. Ora even had enough money to pay a teenage girl by the name of Emma Hansen to stay at the home and help Nellie with the everyday chores of a typical farm household. This would have consisted of such things as cooking, cleaning and tending to the children's needs.

Ora and Nellie became well known in their community and had many friends. Just as they had been given much, they decided to share the bountiful harvest of their lives with others. And so they took in a young orphan girl named Grace Reed.

Grace was born in Nebraska to Charles and Elizabeth Reed in 1889. She and her sister, Ruth, had been orphaned by 1895 and lived in Toledo, Iowa, with their grandmother and aunt. In about 1904, young Grace was sent east to rural Scott County to live with the Drenter family, who were to care for her until she turned eighteen.

Although Grace was almost certainly expected to do her part in all the household chores, Ora and Nellie treated her as one of their very own children, as if she had been part of their lives from the very beginning. She

wanted for nothing as she grew up and was loved and cherished on a level equal with the other young ones of the household.

Harry eventually bought his own farm right across the road from Ora. He was also successful in his endeavors, and his farm thrived. Harry, too, had many friends. But he was still single. He was still alone. As the hours and the days passed, his eye settled on young Grace. She was young, attractive and full of life. She would probably make anyone an excellent wife, and Harry thought to make her his own. With his heart full of love and good intentions, he approached Grace and proposed marriage to her. But, much to his disappointment, she wanted nothing to do with him in that way.

Grace was only in her middle teens, while Harry was in his thirties. Besides the age difference, Grace had been raised alongside his nieces and nephews and probably, like them, looked at Harry as an uncle. Although she might have loved him as a child would a beloved uncle, she did not want to marry him or bear his children.

Disappointed but not entirely deterred, Harry approached his brother about his predicament. Talking with Ora and Nellie, Harry asked them to intervene on his behalf. He wanted them to persuade Grace to take a chance with him, to tell her that Harry would make a good husband for her. And if that did not work, they should force her to do it. But they agreed with Grace. Ora and Nellie saw absolutely no reason that they should talk her into marrying Harry, and they most certainly would not force her into doing something that she was so dead set against.

What had been disappointment turned quickly to anger. Harry raged at his brother, but Ora stood his ground. Harry despised Ora for his decision, and their once friendly relationship turned bitter and hostile. Harry sat on his farm, nursing his wounded heart. But soon, those wounds began to fester. His anger and rage slowly condensed into hatred. He even told some people that one day he would murder both Ora and Grace, the girl who had spurned his love. For the next year, Harry sat and nursed his hatred, but made no more threats.

During that time, Grace began to see a local boy, a teenager named Sam Moore. He was close to her in age and had grown up only about four miles away from the Drenter farm. When Sam came over to see Grace, he would sometimes talk with Harry on his farm across the road. He had heard that the older man had made threats against Grace, but Harry never said anything like that to Sam. Rather, he was always cordial and friendly.

But inside his house, Harry allowed his true feelings to show through. His housekeeper, Hattie Goldsmith, often heard him make threats against

his family across the road. Harry blamed his inability to win Grace's heart on them. Somehow, they were preventing him from marrying her. Hattie heard him say that after he had killed Ora and his wife, he would commit suicide.

One Sunday, Sam asked Grace to attend evening services with him at Summit. She readily agreed, and they soon set out together in Sam's horse and buggy. For whatever reason, this pushed Harry over the edge. His inner hatred and rage toward Grace finally boiled over. She had rejected him. She had spurned him. She would not have him for a husband. That was fine, he thought as he took down his Winchester-model shotgun. If Grace Reed would not have him, then she would not have anyone. Ever.

As he started to walk out of his house, he stopped to talk with Hattie, shotgun in hand. He told her that if she told anyone what he was going to do or tried to interfere in any way, he would kill her, too. With that, he left.

Hattie was terrified. She did not want to get in Harry's way, so she waited. After a while, when she felt it was safe, Hattie exited the house through a side door and made her way to Ora Drenter's farm.

While all this transpired, Sam and Grace were at Summit Church, enjoying evening services. For decades, the gospel message had been preached underneath that hallowed roof, and that night it was heard by the young couple, as it had been many times before. After the minister had finished, they filed out of the building with the rest of the congregation, got into Sam's buggy and began their trek toward home.

As they drove down the old dirt road, they must have talked and enjoyed the pleasure of each other's company. Listening to the steady beat of the horse's hooves on the ground and the soothing sound of the buggy wheels turning must have been relaxing. And underneath it all, the teenagers might have been growing more comfortable with each other, enjoying the fruition of their relationship into something closer to being in love.

Soon, the teenagers came within sight of the Ora Drenter farm. How right life must have seemed to them. Nothing could be better in the world. It must have taken their minds a moment to understand what was happening when Harry Drenter stepped out from behind a tree alongside the road.

Reality snapped rapidly back into focus as Harry raised his shotgun. Sam Moore screamed at him not to shoot and instinctively ducked his head away from the imminent attack. Harry aimed at Grace and pulled the trigger. The shotgun found its deadly mark, striking Grace full in the head. Half of her face was torn away as she slumped over, dead. Some of the stray scattering of shot also hit Sam, who cried out in pain.

Sam Moore took Grace Reed to Summit Church in a buggy probably very similar to this one. *Courtesy of Davenport Public Library.*

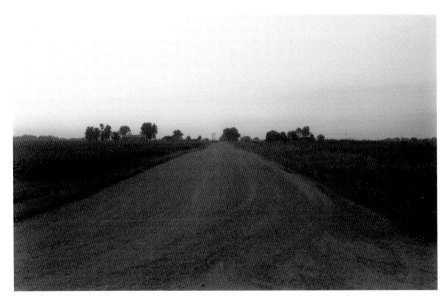

Harry Drenter brutally murdered Grace Reed along this road in 1906, blowing half her face away with a shotgun. *Author's collection.*

The horse, frightened by the loud noise of the shotgun blast, bolted forward toward a ditch alongside the road. The buggy overturned, and Sam half fell, half jumped clear, breaking some of his ribs in the process. Afraid for his life, Sam got to his feet as quickly as he could and made his way to Ora Drenter's farm.

Harry did not chase after the young boy, nor did he shoot at Sam as he ran away. Evidently in his mind, his job was done. Still holding his shotgun, Harry walked back home, around the house and into the backyard.

Ora Drenter had been sleeping when the sound of the shotgun blast woke him up. He probably was still trying to figure out what to make of it when he heard someone banging on his front door. Quickly, he got out of bed and went to see who it was. He opened the door and found Sam Moore there, nursing his wounded arm. Ora brought the young man inside.

Sam must have been scared half out of his mind. The adrenaline rush that kicked in when Harry had shot him was probably close to wearing off, and the pain that it had helped to suppress was rapidly starting to register. While Ora began to tend to Sam's wounds, he probably heard the shotgun go off a second time.

The authorities were called. Ora stayed in the house, looking after Sam until the Scott County sheriff and one of his deputies arrived. The policemen were filled in on what had happened up to that point. Ora, satisfied that Sam was in a good condition, left with the two policemen to find Harry.

They crossed the road, wary of the murderous Harry. They walked through the front yard and found nothing. The side yards were also empty. Finally, the search party found the body of Harrison Drenter in the backyard, lying in the grass a short distance behind the house. He was dead, the top of his head blown off. The second shotgun blast had been the sound of Harry Drenter committing suicide.

The community was stunned. What had driven such a successful man to murder an attractive young woman who was still so full of promise? Both Ora and Nellie agreed that Harry was not in his right mind. But was it living with the fact that the woman he loved would never love him in return that drove him to madness, or was it something else? With his death, the question would remain forever unanswered.

Elsewhere, the world continued on. Harry was buried in the cemetery just on the south side of Summit Church. Grace's body was sent back to her remaining family in Toledo, Iowa, and buried there. Sam Moore would recover from the wounds he suffered that day. Ora and Nellie lived on for

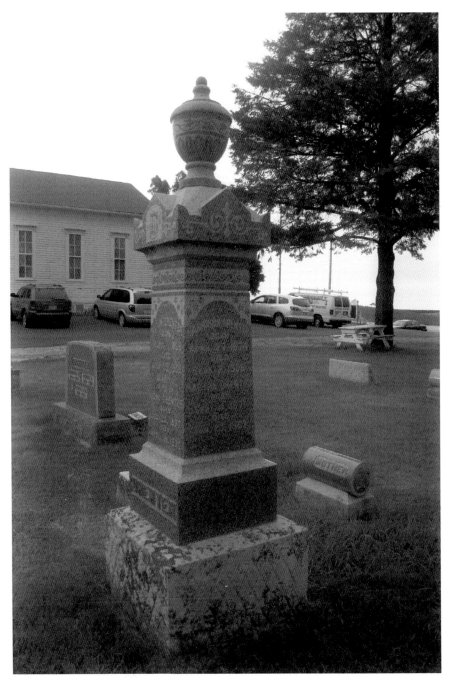

The final resting place of Harrison Drenter at Summit Cemetery in rural Scott County. *Author's collection.*

several more decades, until they both died and were buried in Summit Cemetery near Harry.

Eventually, the dirt road that saw the murder of Grace Reed was covered in gravel, making it much easier to travel on. Utica Ridge Road was paved with asphalt and concrete. And Summit Church still had service every Sunday until 1972, when it was decommissioned as a Presbyterian church. But the building still stands, preserved and watched over by the Scott County Historical Society, the last witness to a long-ago chain of events that ended in tragedy.

MADNESS, SUICIDE AND CHOCOLATE

S tarting in about 1820 and ending at the turn of the twentieth century, cultural norms in Western Europe began to shift. At the same time, things were also changing in the United States. America began to experience an enormous influx of immigrants from the western portion of the European continent and the United Kingdom. All the immigrants and their families had their own reasons for coming to America. Sometimes, it was a single factor that drove them, while for others it was a combination of several.

For some, the unchecked religious freedom that could be found in the United States was an enormous draw, just as it had been for groups such as the Puritans before them. Others were fed up simply with having to deal with renting a small tract of land in Europe and were tempted by the promise of having a large farm of their own, carved from the enormous tracts of land becoming available in the slow crush of American expansion toward the west.

In Germany, one such man was Nicolaus Nehlsen. Nehlsen was a family man. He had a young wife, Margaretha, and three small children: Mary, Emma and John. They were happy living in the old country, and they were proud of their German heritage. But, like many of his fellow countrymen, his eyes turned toward the west and the United States of America.

There were opportunities for a man who worked hard in America. And there was plenty of land. A man could have as much good land as he wanted there, to work and make something of. It would not be the easiest thing in the world to do, but it would not be the hardest, either.

Nicolaus knew that money would be tight at first. But money was always tight when you had to spread it between a wife and three young children. And with all that land, they could grow as much food as they needed. As a matter of fact, they would probably have more than enough land left over to grow crops specifically for profit. They would even have extra room to raise livestock.

Nicolaus could have gotten these ideas from anywhere. There were various accounts flooding into Europe extoling the various virtues of the United States. Some of this information came from family letters, sent from immigrants who had already traveled to America back to their families in the old country. Others were published accounts from settlers and travelers, writing about what they had seen and experienced. All of these were designed to bring people to the New World.

Wherever he had heard about it, Nicolaus was starting to think about making the move. He knew they would have to leave their family and friends behind in Germany and the life that they had made there. But America had a large German population already, so he was sure that he could find some fellow German immigrants to fit in with. Besides, even if they did not find any, the opportunity was just too much to pass up.

For Nicolaus, or Nick, as he later became known, America must have truly seemed like the land of golden opportunity. After going through a brief period of discussion and deliberation with Margaretha, they made the decision to cross the Atlantic and settle in the United States.

Making the passage across the Atlantic could be a dangerous proposition. For prospective immigrants, the problems started as soon as they stepped out of their homes. Whether they were traveling by themselves, in pairs or in family groups, there were still dangerous stumbling blocks on the road to America that could end your trip before it began. At the harbor, con men ran scams on unwary travelers. Some of them sold fake boarding tickets for ships or tickets with incorrect departure dates. If an innocent family bought one of these latter tickets, they might be stranded in a harbor town indefinitely until their ticket date was valid and would be accepted. Once on the ship, sea travel could be perilous. In addition to the various dangers presented by the tumultuous ocean, conditions on the ship could present just as much of a danger. On some ships, passengers were packed in as tightly as possible. The cramped, unsanitary conditions allowed sickness and disease to run rampant. There were many who did not survive these ocean voyages.

If an immigrant did make it across, as many of them did, they might have found that the American experience was a little different from what they

were expecting. In Europe, farming and community life revolved around the village. The village defined a person socially and culturally and provided all the needs of its residents. Everyone was obligated to one another in some way, binding them all together. American farming and community, on the other hand, was much more solitary. There was no system of obligations. Everyone was much more isolated, each farm almost functioning as its own self-contained business. Instead of seeing one another every day in the common fields of the village, American farmers would often spend long hours alone or with only their family members for company. And underlying all of this was the fact that an immigrant may not have enough money to buy or rent his own farm.

Despite all the dangers and hardships, Nicolaus and Margaretha had made up their minds. Saying goodbye to their family and friends in Germany, the young couple packed up their children and set out. All of them survived the journey and set off across America to Scott County, Iowa, and their new home.

In many ways, Scott County was an ideal place for German immigrants to settle. In 1848, a group of individuals from a place in northern Germany called Schleswig-Holstein had taken part in a revolution against the country of Denmark. Unfortunately for them, they lost. Knowing that things would get very bad for them if they remained in Schleswig-Holstein, many of them boarded ships and came to the United States, where they ended up in Scott County. Many of these individuals—later called "Forty-Eighters," after the year they launched their failed revolution—were extremely well educated and very liberal in their political views. They were opinionated, intelligent and well spoken. They were proud of their German heritage, and they brought it with them. The Forty-Eighters helped found German-language newspapers, in addition to various cultural societies and institutions.

For those who had made the treacherous journey from Germany to Davenport in those years, it must have been almost like coming back home. There were several German-speaking people both in the city and outside of it. Newcomers were often taken into the community and welcomed. New immigrants had a support system consisting of people with a similar cultural background and mindset. The German community was strong, and they worked hard to create a sense of community among their fellow immigrants from the old country.

It was this environment into which the Nehlsens moved. Nick and Margaretha probably felt a sense of belonging. For people who had left everything that they had known behind them, it gave them a real sense of

stability in their lives to come into such a welcoming community. As they learned the English language better and adjusted to American culture, the Nehlsens always had a place to go that seemed comfortable and familiar.

The Nehlsens quickly found a farm along Utica Ridge Road, a rural road northeast of Davenport. It was about 160 acres of rich Iowa soil, ready to be turned and planted by people with a will to do so. Nick had been dreaming of this opportunity since he and Margaretha had first discussed coming to America. And now they were here, ready to bring their dream to life in the farmlands of Scott County.

Over the next several years, the Nehlsens became very successful. The land was bountiful and provided not only food for their family but plenty to sell as well. They bought livestock and began raising that, too. And it was not only the farm that grew.

Margaretha and Nick had six more children in Scott County: Jacob, Otto, Peter, Louis, Dora and Meta. The boys worked in the fields, learning farming and other skills from their father. The girls, on the other hand, learned cooking, keeping house, sewing and several other skills that were mastered by farm wives of that day and age. Together, the men and women of the family divided the essential labor of the farm and worked together toward its overall success.

The Nehlsen farm was located along Utica Ridge Road, pictured here. *Author's collection.*

By 1910, Mary, the eldest child, had moved to Galesburg, Illinois. Their five sons were living at home, helping to tend to the crops, livestock and various chores that go along with running a farm. Young Meta and Dora probably followed their mother around the house, taking care of things as they were able.

Young Emma, now nineteen, decided to go to a nearby farm to work as a housekeeper for a man named Glen Port. He lived only a short distance away from her family, so Emma was never far from home. While she was employed there, Emma had no issues with Glen or his family, and they were satisfied with her work.

During her employment there, Emma met Glen's father, John Port. He was a fifty-year-old widower, and he apparently enjoyed Emma's company. He would take her for buggy rides, where they would talk and become better friends.

Eventually, John Port left the immediate area and took up residence in nearby LeClaire, Iowa. About the same time, Emma quit working for Glen Port and became the housekeeper of another local man named Claus Willer.

Willer was in his mid-forties. Like the Nehlsens, he had also emigrated from Germany. Similarly, he had also settled down in Scott County and quickly turned his hand to farming. Eventually, Willer married Amelia Oetzmann and settled into the comfortable routine of rural life. The couple never had any children, and Amelia passed away in 1908.

With no wife or children to help, Willer had to take care of all the household duties in addition to his regular farm chores. In a time when many things had to be done by hand, it might have been difficult for Willer to take care of everything himself. So, he hired Emma Nehlsen to come to the farm and take care of all the cleaning, cooking and washing.

Rural life could oftentimes be lonely. While there were neighbors who were relatively close by, there were several hours of the day when Willer would have been alone, toiling in the fields. Finishing his work, he would have come back to an empty house. Having a housekeeper would give him someone to talk to and interact with.

One night, Emma came to talk with Willer shortly after they had eaten dinner. She told him that she was quitting her position as housekeeper that very night and asked Willer to pay the rest of her wages. At first, Willer thought that Emma was joking, but the younger woman insisted that she was not and, once again, asked for her money. He was surprised, almost shocked, and asked her why. Emma informed Willer that she was going to go work for John Port in LeClaire and that he was waiting for her at the end of the lane.

Willer collected himself and then paid Emma the wages that he owed her. As he did, he asked Emma why she had not given him due notice and allowed him sufficient time to find a new housekeeper. Emma told Willer that she did not want him to tell her parents about her new arrangement with John Port. Her wages collected, Emma left the employ of Claus Willer and moved to LeClaire.

While this might have normally been an acceptable arrangement, there was a general inclination toward the idea that Emma and Port were much more than employer and employee. If people asked, John would tell them that there was nothing happening. Emma was simply his housekeeper and nothing more. But still the idea persisted.

Whether he was or not, the family was scandalized, causing severe friction among the Nehlsens. Nick even threatened Port, telling him in no uncertain terms that Port must release Emma from his employ and return her home as soon as possible. If he did not, then Nehlsen would kill Port.

Claus Willer felt just as strongly. He had developed feelings for Emma. Maybe he had fallen in love with her, or maybe he was just lending support to the Nehlsen family, looking out for Emma as if she were his own daughter. Or, perhaps, Willer just wanted someone to talk to again after coming in from the fields to keep the loneliness at bay. Whatever the reason, Willer's feelings for Emma, whatever they actually were, spurred him forward into action.

Purchasing a handgun, Willer brought it home to his farm and began to practice with it. When he thought he had practiced enough, he rode to LeClaire to find Port. The older man must have been warned or somehow found out about it because he wasn't there. Dejected, Willer left town, still determined to bring Emma back. He returned to LeClaire several times, loaded pistol with him, but every trip ended fruitlessly.

After the last time, Willer was distraught. Emma was not going to come home. The man to blame, John Port, could not be found. Willer, who wanted so desperately to succeed in his task, could not win. So he went back to his farm, where nothing awaited him. No wife, no children and no Emma Nehlsen, housekeeper.

People stopped seeing Willer soon after that. He did not come into town to socialize or buy needed goods. No one saw him in the yard doing chores. No one saw him in the fields tending to his crops. Perhaps, after watching what the man had been through, people decided that he needed some time to nurse his losses and recover his inner balance.

But after several days without seeing him, some of his neighbors began to grow concerned. On April 21, 1910, some of them went to the Willer farm

and began searching for him. The silence when they opened the door must have been oppressive. It was deep, only broken by the sound of summer insects and the livestock. The good-hearted neighbor found Willer in his bedroom, dead. Apparently, after coming home for what would be the last time, Willer could not handle the stark reality of his life anymore. The loneliness and the quiet had finally taken their toll. Willer had tried his best to fight them but had lost. He had gone into his bedroom with a vial of laudanum and drank it down, ending his life.

Everyone was shocked at this turn of events. Nobody expected his outlook to turn so sour that he felt the only recourse available to him was suicide. The county coroner was consulted, and an inquest was held. The official result was that while it was clear Willer died from laudanum poisoning, officials were not sure why he had done it.

A few months later, in July, John Port decided to make an honest woman out of Emma, and he asked her to elope with him. Emma agreed, probably eager to shed her "housekeeper" role and take on a new one—that of Mrs. John Port. Plans were made, and the two apparent lovers moved to North Dakota, leaving all the drama and scandal of the past year behind them.

The Nehlsens were stunned. With nothing left behind, the only thing they that had of their dear Emma was the memory of their daughter. Obviously, they did not approve of the relationship. Nick was very open about his opinion, and it is very likely that Margaretha shared it as well. Perhaps knowing this, and knowing that they would never gain the approval of the family, the elder John and young Emma chose to move away rather than face years of disapproving looks and attitudes.

Losing a daughter to a man whom they did not see as suitable for her was bad enough. But with the added pain of Claus Willer's suicide and all the drama that had transpired before that, it must have left a stinging pain in the family. While it can be said with almost certainty that the elopement left a hollow ache among all the older family members, no one seemed to feel it more than Margaretha.

After Emma had left with John Port to go to the Dakotas, Margaretha's mood darkened. She would sit and think about the whole situation endlessly. She had even begun to dream about what had happened, talking in her sleep. Margaretha's obsession with Emma and Port had seeped down into her subconscious, and now even her innermost mind strived to talk sense into her wayward daughter.

And then, like the sun emerging from heavy clouds on a gray sky, her mood suddenly brightened.

On the morning of August 3, Nick had to go to nearby Eldridge, Iowa, to sell some of his hogs. Good cheer had seemingly returned to the home, and Margaretha seemed to be in good spirits. She was so happy that morning, carrying out her daily chores and tending to her youngest daughters. As her mood was brightened, the moods of Nick and the children probably were as well. At about two o'clock that morning, Nick took his livestock and started driving them toward Eldridge.

Nick returned home about mid-morning. Given the improvement in Margaretha's mood and a successful sale, he was probably smiling, finally glad to have a little happiness in his life after the events of the past few months. One can only imagine and speculate what happened next. Perhaps he was like many other fathers who expect their small children to greet them at the door so they could embrace them with welcoming and loving arms. No matter what he expected, he was met only with a cold, stony silence.

Nick must have wondered where everyone was as he wandered into the kitchen from outside, looking for his family. Next, he entered the bedroom and found them.

They were lying on a white sheet that had been spread out on the floor. The children were unnaturally still and composed. The two young girls did not move. Their mother lay near them. A grim fear must have come to Nick's mind as he moved forward and laid his hand on them. As his bare hand touched their cold flesh, his fear became stark reality as he realized that his wife and two youngest children were dead.

The horror that Nicolaus Nehlsen probably felt in that moment must have been overwhelming. As his mind reeled, he might have noticed that Meta's and Dora's clothing had been laid out for them to wear. Coming suddenly to his senses, he ran out of the house and did not stop until he reached a neighbor's house a half mile away. He tried his best to tell his neighbor H.E. Sawyer what he had seen in his bedroom, but he could not. Nick's tongue was frozen by shock and fear. Sawyer poured cold water on Nehlsen, trying his best to bring his friend back to his senses. Finally, Nick described what he had seen.

Sawyer immediately took Nick back home so that he could verify the story for himself. He was horrified at the sight that awaited him in his neighbor's bedroom.

The authorities were called and the bodies removed to the funeral home. After a short investigation and autopsy, strychnine was found in the stomach of one of the children, and three empty vials of the poison were found in the outhouse by the family home.

The conclusion was that sometime after Nick had left for Eldridge and the boys were all out of the house, Margaretha had gone into the bedroom and laid out the white sheet and the children's good clothes, presumably for them to wear at their funeral. Then, taking chocolate that she had laced with some of the strychnine, she fed the poison candies to her innocent daughters.

Once they had succumbed to the vile combination, Margaretha carefully laid out their tiny bodies on the sheet. When she was finished, she consumed some of the same deadly sweets as she lay down next to the still forms of the girls so that she, too, could die.

In the aftermath, Nick and his sons finally took the time to speculate over what had caused their beloved mother to commit such a horrible act. At some point, their thoughts turned to Emma, John Port and Claus Willer.

First there had been Margaretha's deep depression. Her mood soured, and she dwelled on Emma's behavior. Sometime along her dark inner journey, she must have made the decision to end her own life. But that still left the children, Meta and Dora.

There was some idea that, somehow, in her troubled mind, Margaretha was afraid that her wayward daughter Emma would come back and take them away. Or maybe, Margaretha just could not stand the thought of

The entrance to Pine Hill Cemetery, where Margaretha Nehlsen and her daughters Meta and Dora were buried in 1910. *Author's collection.*

being away from her beloved little ones. Perhaps then, once she had made her decision, her mood shifted back and she was happy, knowing that her suffering would soon be over.

But while her inner torment may have come to an end, Nick's had just begun. His wife of over twenty years was dead. His youngest two children were also gone, killed by their own mother. And he had no answers. Even though Nick was asked so many times, he was never able to give a definitive answer to that burning question—why? All he had were ideas, speculation and three loved ones to bury.

The funeral was held at the Nehlsen home along Utica Ridge Road. Being successful farmers and having lived in the area for nearly two decades, the Nehlsens had many friends and associates. They began to arrive around mid-morning, around the time the funeral services for the family were supposed to begin. More and more people kept filing in, not stopping until several hundred were present. The house was full almost to bursting that August morning from the number of people who had come to pay their final respects to Margaretha and her two daughters. Margaretha may have committed a horrible crime, but she had still been a good friend and neighbor to many of them.

After the funeral was finished at the home, the coffins of the deceased were carried out into three waiting carriages. Flowers from all the various guests covered the three coffins. There were so many that they had begun to mound against the front side of the caskets like a colorful snowdrift.

First one girl and then the other was loaded into her own pure white carriage, each one pulled by two snowy white horses. Margaretha was loaded into a black carriage attached to two coal-black horses. Once the coffins were secure, the funeral procession was begun.

Margaretha and her daughters were to be interred at Pine Hill Cemetery, north of the main part of Davenport. From the Nehlsen farm to their final resting place, the deceased mother and her two children served as the centerpiece for a somber procession.

Once at the graveyard, the minister said some comforting words to those present. Then, one at a time, each coffin was lowered into the ground by the pallbearers. Both girls had one of their brothers as a pallbearer, but none of the family helped lower Margaretha.

Soon, all was finished, and the vast crowd departed.

In the end, it will probably never be known what tortured reasoning drove Margaretha Nehlsen to kill first her two youngest daughters and then herself. Perhaps it had to do with her beloved daughter Emma, who was linked to

Left: Three hearses, one black and two white, carried the remains of Margaretha Nehlsen and her daughters to their final resting place along this road. *Author's collection.*

Below: The graves of Claus Willer and his wife. Willer's suicide contributed to Margaretha Nehlsen's mental instability. *Author's collection.*

The graves of Margaretha Nehlsen and her two young daughters, Meta and Dora. *Author's collection.*

one man's suicide and had caused such bitter disappointment by moving away with another man whom they did not approve of.

Or perhaps her decision had nothing to do with that at all. Maybe Margaretha, for whatever reason, just broke down inside one day and began to conclude that suicide was the only way she could find peace.

No matter what the underlying cause, the cold, hard fact is that Margaretha Nehlsen fed her two young daughters chocolate candies laced with strychnine, cutting their young lives cruelly short. Their souls, full of the untapped and undetermined potential of life, were ripped shockingly away from the material world.

Maybe Margaretha, her poor soul tortured by unknown demons, finally found rest and peace under the well-kept lawns of Pine Hill Cemetery.

CHAPTER 4

THE POSTMISTRESS, THE MAILMAN AND HIS WIFE

I t was a day like most any other on June 11, 1916. The sun was shining, warming the town of McCausland, Iowa, far beneath it. All about town, people went about their daily routines. Some conducted their business at the bank or mercantile, while others took care of their daily chores of washing clothes, cleaning houses and tending to crops or livestock.

However, on one street in town, things were anything but quiet. As some watched, two women fought. One had two children with her and was defending herself against the other, who was raving and cursing. During the scuffle, the mother fell in the dirt and started to scramble for a tangle of packages and stamps that had fallen nearby. The one left standing started to advance toward the fallen one.

The mother reached the pile of packages and quickly started rummaging through it. She found what she was looking for: a handgun. She brought it up and leveled it at her assailant. In the most commanding voice she could muster at that moment, the mother yelled at the other to stop.

Fearless, the angry woman started forward again.

What happened next would leave a scar on an otherwise quiet midwestern town.

BUTLER TOWNSHIP IS LOCATED in northeastern Scott County. It is made of rolling hills that glide and swell across the landscape like waves on the ocean. The Wapsipinicon River flows through the northernmost portion of the

township and forms its border on that side. Like the rest of the county, the soil is rich and black and yields good crops more often than not. Because of this, agriculture was prominent there, with only the river bottomland directly around the river still untouched by the plow and harrow.

In 1836, a man named Henry Harvey Pease, along with his partner, John D. Grafford, bought five hundred acres of land in the region. Pease had been born in Massachusetts in 1794. From that time until he was fifteen years old, he assisted his father, a farmer, in the various tasks and chores of that trade. At fifteen, he entered into the fuller and dyer's profession, apprenticing in it for six years.

Moving from Massachusetts, he went to New York, where his brother Daniel lived. He kept working as a fuller and dyer for a few years but took the opportunity to travel throughout the area during that time. During that phase of his life, Pease seemingly had a restless spirit, liking to travel and see new things.

He eventually grew bored living in New York and moved west to Ohio, where he worked various jobs, including one as a teacher in a rural school. Still restless, Pease continued moving west to Indiana, where he started a school and began to teach there.

Unfortunately for him, Pease fell gravely ill for several months, leaving him bedridden much of the time. After he recovered, he moved back to Ohio and taught there for a few years before moving back to Indiana and teaching there.

Selina Street in McCausland, Iowa, where Olive Adkins was shot to death in 1916. *Author's collection.*

Ready for another career change, Pease moved in 1827 to Galena, Illinois, where he mined lead for the next five years. In 1832, he moved again, this time to the thriving city of Dubuque, Iowa. Dubuque was very much a mining town in those days, providing the region and the nation with lead. Like many such towns, it could be a rough and dangerous place. Stepping up to the challenge of preserving law and order, or at least keeping the noise levels to a dull roar, Pease became a deputy sheriff. However, like many men of that era, he was not satisfied to wear only one hat. In addition to his various duties as a sheriff's deputy, he also ran a general store with his partner, Warner Lewis.

In 1837, he returned briefly to Indiana to marry Nancy Britton, a young woman he had met several years before while living there.

By 1838, Pease had grown tired of living in Dubuque and longed to move once more. So he packed up his worldly goods and moved south to a piece of land that he had purchased in Butler Township. Once there, he built the first cabin in that area.

Presbyterian services were held in the little cabin that same year, given by James and Alexander Brownlie, who were founders of the nearby town of Long Grove. Like many pioneer locations, the cabin would host traveling ministers and preachers of other Christian denominations as well, including Catholics and Methodists.

The cabin also became the first post office in the township, and Henry Pease became its first postmaster. At this time, the postal service in the state of Iowa was almost brand new, having started in Dubuque in 1833. Individuals and families who came here from other places wanted a way to communicate with their families and friends back home. Various business owners also had a desire to communicate with their associates in distant locales.

In the early days of the post office, travel was, as it was in most other pioneer endeavors, difficult. There were no railroads and hardly any roads to speak of. Rivers had to be forded or a ferry taken across them. Mail did not come regularly but, rather, at random intervals. As travel depended so much on the weather conditions, it could take some time before any mail was received—if it ever arrived at all.

The postmaster handled the mail, both shipping and receiving. The pioneer post office was usually some kind of store or even a house owned by the postmaster, and all mail was initially delivered to it. In pioneer times, people would travel great distances to collect their mail, as there was no delivery service directly to their homes at that time.

The postmaster was also responsible for the collection of postage fees. Official government acts regulated postage fees in the United States based on distance. Like many pioneer transactions, a person could either pay the assigned mail fee to the postmaster or, if they could not afford it, the postmaster could essentially accept an IOU toward the time the person could afford the fee.

Over time, Butler Township began to grow. More people began to move into the region, mostly farming and raising livestock. Better roads were made, and a railroad line was to be built through the area. This line was to connect the cities of Iowa City and Clinton, Iowa, by 1882. One of the stations for the line was to be located on the eastern section of a new town that was in the process of being built.

The town was named McCausland, after one of its most successful local men, D.C. McCausland. His father, John C. McCausland, had traveled west and settled in Butler Township in 1855. John taught D.C. how to run a farm, which included how to handle livestock and various forms of farm equipment. In 1880, D.C. decided to buy his own farm within the township.

Like Henry Pease before him, McCausland was a civic-minded individual who had a keen interest in building up the region where he lived. After the town was built, D.C. opened the first general store there and ran it for several years. He also became McCausland's first postmaster in 1883.

By that time, the postal service had changed much since the days of Henry Pease. The railroad was now the primary method of sending mail, and it was much more efficient and successful than the pioneer methods of steamship and horse travel. As such, the latter methods mostly faded away, replaced by the more reliable railways.

By 1900, the telephone had come to rural America, connecting people in those rural communities with far-away neighbors in a way that they never had been before. For the first time, it was possible to talk with someone located in Davenport from the comfort of your own home or office in McCausland. But it still did not eliminate the mail service. Letters, business documents, advertisements and catalogues continued to be sent all across the nation and even the world.

At the end of 1899, the United States Postal Service instituted what was called rural free delivery service. Starting in Maryland, the service quickly spread across the nation. For the first time ever, rural families received mail at their own homes. No longer did they have to travel to a nearby post office to pick up their mail. In Iowa, there were nearly three hundred rural routes across the state by 1901.

Mae Garber was the postmistress of the McCausland Post Office, which was located on this block. *Author's collection.*

But McCausland, unlike some rural towns, kept its post office. By 1916, the building was still very much in use. The postmaster was now a postmistress: Mae Garber.

Garber had come to McCausland with her husband, Robert, around 1914 in order to take a position as postmistress. The couple came from South Dakota, where they had lived for several years. She was about thirty-eight years old at the time. Mae and Robert had four children together. Their eldest two children, a son and a daughter, had already moved out on their own. The younger two were significantly younger and still lived with their parents.

Robert Garber, who had suffered from tuberculosis for some time, was finally committed to a specialized tuberculosis sanatorium in nearby Davenport. Unfortunately, he succumbed to the disease and left Garber a widow.

Mae survived, though. She had several family members in the region, several of whom were prosperous and respected landowners. Garber was also an intelligent, well-educated woman, especially when it came to the subject of music. Since she had moved to McCausland, she had even given several area children music lessons.

During this time, she met William Funk. Funk had also come to McCausland from South Dakota with his wife, Olive. Funk and Garber quickly became friendly. Although they had never met before, perhaps having lived in South Dakota gave them a common bond that aided in them becoming friends. In 1915, Garber offered Funk a job as a rural mail carrier, which he readily accepted. What Garber may or may not have known is that Funk had serious problems at home.

Funk had met his wife in Fond Du Lac, Wisconsin. The two had fallen in love and left for South Dakota, where they lived for several years. The couple eventually decided that it was time for a change, so they packed up and moved to McCausland, Iowa, in 1912. Sometime during their relationship, or perhaps even before, Mrs. Funk had developed a severe addiction to the drug morphine. When exactly this started or how long it had been going on will probably never be known. But it is known that Funk took his wife to Davenport to receive treatment for her problem from the Neal Institute, one of several popular institutions of that time that claimed to cure alcoholism and drug addiction. At the time, she seemed willing. And Funk, who loved her, wanted to help her any way he could.

The problem was that the treatment did not come cheap. William Funk did not have the funds to pay for the cure outright, so after some consideration, he decided to resort to some fairly dire measures. He went to the bank and mortgaged both his house and the lot that it sat on in order to obtain the necessary funding. With this, he got the money he needed and took Olive to Davenport.

When the treatment was over, Olive had been cured of her morphine addiction. Funk was ecstatic. He made the trip to Davenport and brought her back home.

Soon enough, William had to leave her alone so that he could tend to his mail route. When he returned, he discovered that Olive was drunk. Although she had apparently kicked the morphine habit, she had replaced it with another: alcohol. William demanded that Olive stop her drinking. For a while, she did. Olive made a real effort and stayed sober for several days. But eventually her demons came calling again, and she once more took to the bottle. Drinking became one of her main focuses in life, and as a result, Olive spent her nights drinking more often than not.

In the beginning, she had some men she knew bring her liquor from the local saloon right in town. William eventually caught on and asked the men to stop doing it. They readily complied, and Olive was cut off for a time. But soon she found a willing butcher from nearby Princeton, Iowa,

to supply her when he came through town once a week. Olive's drinking was spiraling out of control.

William soon had enough. He had been a good husband and put up with the drug addiction. He had even mortgaged the house so that she could kick that habit. And what had she done? Become a drunk. And no matter how much he tried or how much he pleaded, she would not quit. Enough was enough. William and Olive began to argue.

She blamed William's friendship with Mae Garber for their problems. In Olive's mind, there must have been something more to their friendship, something deeper. And she was not going to stand for it.

William had stayed with Olive all these years, steady as a rock. But now he was friends with Mae Garber. Now he wanted to argue with Olive and walk away from their relationship. Look at that week when he had done some plastering work at the postmistress's house. Sure, he was home every night for dinner, but that did not matter.

During their heated argument, she accused William of having deeper feelings for Garber. With those words, William finally snapped. He packed up a few things and left, leaving his angry, drunken wife to fume.

While Funk stayed wherever he could, some of the wealthy citizens of McCausland and Butler Township took pity on his poor wife. She had no job and no apparent means of supporting herself. Charitably, they paid the rest of the mortgage on the house and lot that William had taken out for Olive's cure. But that was not the problem that Olive had. Mae Garber was.

Tension simmered between the two women. Olive hated Garber because she thought that she had stolen away her husband. Garber was half-terrified of Olive and steered clear of her as much as possible. Ever since Olive had convinced herself that the postmistress was stealing her husband, she had become verbally and physically abusive toward Garber. Once, while passing by Garber's daughter in the street, Olive reared back and smacked the young girl across the face without provocation. Another time, Olive simply walked into Garber's home, picked up a book and struck the postmistress with it. The town constable spoke with Olive about it, warning her to stop some of her behavior. But it did not matter. Olive would start up her abuse again eventually.

But in the midst of these events, an odd thing happened. When asked about his wife, William claimed that he was not married to Olive. And it was the same when people asked Olive about her husband. It was an odd thing to say, but it is quite possible that people, even when they thought the answer

was strange, simply thought that the Funks had decided to divorce and thus no longer claimed the other as a spouse.

People took notice of the couple's marital trouble. In a town as small as McCausland, where you were at least a passing acquaintance with most other people in the area, it was hard not to. People knew one another's business and knew the major problems affecting relationships around town. And the trouble between William and Olive Funk and Mae Garber definitely made waves.

Although her house had been paid for, Olive eventually left to stay with friends. After a time, she asked the family if she could borrow a gun. Olive claimed that William had threatened her and that she no longer felt safe. She wanted something to protect herself with. Understanding her situation, the family loaned her a shotgun.

On Friday, June 10, Olive went to the Garber home. Mae and her two young children saw Olive through their windows, stalking around their yard. Soon, she came up to one of the windows and peered in at them. Olive commanded the family to let her in or else she would shoot through the door.

Mae was terrified. When she looked, she saw a shotgun in Olive's hands. The postmistress quickly latched all their windows and locked the front door. Then she blew out their lights so that the angry woman could not see them inside.

Frustrated by her lack of success, Olive fumed. She shouted at Mae that she would kill her. Then it occurred to her. Mae would have to come out sometime, and Olive knew just how to get to her. She threatened the family one last time, shouting at them that she would see them the following morning. And with that, Olive left.

The next morning, June 11, she ran into an acquaintance of hers, Celia Badger. Olive must have still been furious or at least angry enough to cause concern in Badger's mind. When Badger asked Olive what the matter was, Olive told her that she could not stand her current situation any longer. It had to come to an end, and she was determined to end it that very morning.

Later the same morning, a butcher from Princeton was in town going about his business when he saw something strange. Olive was hiding behind a hedge by the side of the street across from her lodgings, obviously keeping a lookout for something. Another local man saw her doing the same thing. To one person who saw her doing this, Olive told him that she was sunbathing.

A short time later, Mae Garber and her two children came walking up the street. Garber carried some parcels in her arms. There were many people

outside that day. It is likely that the postmistress greeted a few of them as she calmly made her way to the post office that summer morning.

As they walked, they started to come near the home where Olive had been staying the past few weeks. After the events of the previous evening, it would not be surprising if Mae approached the area with some trepidation. Just a few short hours before, Olive had been trying to get into her house and threatening to kill her. But Mae had something with her that might have given her a small amount of comfort.

When she was locked in her house, she was safe. She could lock the doors and bolt the windows. Mae could take her children and hide inside, safe from Olive's anger. But Mae had to work. She had certain duties as postmistress. She could not hide forever.

When she had taken her current position, Mae had procured a .22-caliber pistol in case the need ever arose for her to defend herself and the money that was sometimes kept at the post office. It was kept at her house, and that morning, she had decided to take it with her. Mae had no intention of using the gun, but just having it with her must have made her feel at least a little more secure.

As she moved along her way, Mae noticed something in some hedges next to the roadway. It was a woman! Why on earth would someone be crouched behind a hedge? And then she realized—it was Olive.

Olive stood up as she saw her rival approaching with her two children. She had waited so long, and now, like a hungry cat seeing a fat mouse, she came toward Mae. She shouted a few things and then attacked. She struck at Mae, screaming and grabbing. The parcels that the postmistress was carrying fell into the dust. Mae was knocked down, and when she fell, she remembered the pistol she had kept with her parcels. She began to crawl as fast as she could toward them, while Olive retreated a few steps.

When she reached the packages, Mae thrust her hands among them, desperately searching for her pistol. There it was! She grasped it and began to stand up.

Olive began her onslaught again, knocking the pistol out of Mae's hand. She continued the assault, unrelenting. More blows were exchanged, and Mae fell a second time. Olive was quickly on the widow, kicking her and scratching at her face. During the exchange, Mae once again found the gun. She grasped it and quickly rolled over, pointing the .22 at her assailant. Olive stood there, fuming, glaring at her rival.

Later, some would say that Olive was standing still, while others said that Olive started toward Mae again. Regardless of what they saw, there was

a sudden, loud report that echoed across the street as the pistol fired. The bullet struck Olive directly in the chest, passing through her heart and into her spine. She stood there for a moment, walked a few steps and then finally fell into the dust.

All of this had happened right in the middle of the street, where people had been going about their daily business. As the altercation between Olive and Mae commenced, several of them had stopped to watch. Most, if not all, of them had known about the trouble between the two women but had probably not expected them to get into a fistfight in the middle of the street, let alone see one of them shot.

George Badger, one of these bystanders and one of Olive's friends, ran to her as soon as she fell. Reaching her, he knelt down and scooped the wounded woman into his arms. Olive saw his face and recognized it. She looked at him, whispered his name and died.

Mae stood up, the gun still in her hand. Calmly, she turned and began to walk away. The postmistress went directly to the home of a friend, Harry Carber. Once inside, she almost immediately broke down into hysterics. Later, the deputy marshal of the area dropped by the house and placed Mae under arrest. She was still in a panic, and when she would not calm down, a local doctor was called. He came by and gave Mae an injection of morphine to calm her nerves, after which she was allowed to rest. At noon, a sheriff's deputy picked her up from the Carber home and took Mae to the county jail in Davenport. Mae had been fairly calm during the entire car ride south, but when she saw the jail, she began to break down again. A few policemen had to assist her inside, where she spent the rest of the afternoon sleeping.

Almost immediately after the shooting, both law enforcement and the county attorney wanted to talk with William Funk. They felt that the man had some of the answers that they were looking for. Funk admitted to them that he had told the truth when he explained to locals that he and Olive were not married. Although she was known as Olive Funk in McCausland, her real name was actually Olive Victar Adkins. They had lived together for nearly nine years but had never been married.

He went on to tell them about Olive's morphine addiction, the Neal Institute cure and her subsequent descent into alcoholism. Funk explained that he had proposed marriage to Olive on several occasions, but she refused to marry him as long as she was an addict. That was part of the reason he had mortgaged the house and lot—he was making a last-ditch effort to cure her.

Funk also claimed that Mae was only ever an acquaintance, that there had never been anything more than friendship between the two. He had been to Garber's home, yes, but that was initially a weeklong plastering job for her. Funk had returned home to Olive every night for dinner. According to him, the only times he returned to the postmistress's home was to drop off money orders for the post office. Funk also told them that Olive had never threatened Mae's life.

But townspeople notice things, especially in small towns with fewer people to see. Several people said they had seen Garber and William Funk together many times. The police continually asked Funk about this, and he became confused. But he would never admit to having any kind of relationship with Garber outside of what he had already claimed.

At the Scott County Jail, Garber was still recovering from the aftereffects of the shooting. She had suffered a tremendous strain and was admitted to the hospital wing. When questioned, her voice was soft, barely above a whisper. She related how she had seen Olive behind the hedge, and how Olive had attacked her when she had her arms full and was with her children. Mae went on to explain how she had reached for the gun, which was tangled up in some stamps, and had pointed it at Olive to scare her. Mae professed that she had not realized the gun had fired and was surprised when Olive fell to the ground and did not get back up. It had never been her intention to shoot Olive, regardless of what had happened the night before or the subsequent attack.

Police also searched Olive Adkins's belongings. They found the shotgun that she had borrowed from her friend, but it was unloaded and they did not find any shells for it. They also found two letters. One was an answer from Fond du Lac, Wisconsin, stating that it had no marriage record for an Olive Victar Adkins.

The second was seemingly addressed specifically to Olive, although it was unsigned. It stated that the writer was tired of being bossed around by Olive and that he was going to pay off the house, procure the deed to the property and kick her out.

Soon after the murder, the county coroner, J.D. Cantwell, held an inquest at the McCausland Town Hall. The room was packed with people who were curious about what would come out during the questioning. There were several people who, finding there was no space for them, watched through the doorway or looked in through the windows.

One of the standout witnesses during the inquest was Mae Garber's seven-year-old son, Lloyd. He told the assembled crowd about the poor

relationship between his mother and Olive Adkins. The young boy went on to relate the events of June 10 and 11. Lloyd also explained that William Funk had not been at the house that night. He said that entire weeks would go by without Funk ever being there. The last time had been the previous week, when Funk had stopped by to borrow an umbrella.

Garber's twelve-year-old daughter, Norma, corroborated her brother's testimony.

However, although many facts matched up, there were some contradicting stories. An employee at the McCausland Savings Bank, who had watched the fight from the front steps, said that Olive Adkins was not attacking Garber when she was shot but was rather standing still. Others had different versions of where Garber's gun came from.

Also, several people around town claimed to have seen William Funk and Garber together on several occasions. Many of Garber's neighbors also stated that they had seen Funk at her home many times, including the night that Olive Adkins had tried to gain entry. And there were some who whispered of even darker rumors. Some said that Olive had an affair with Garber's older daughter, who was married to a local man who ran the bowling alley in town. When the husband found out about it, he gathered his family and moved away. It was soon after that that Funk had approached Mae and befriended her.

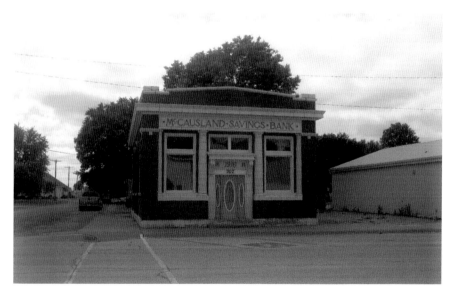

The McCausland Savings Bank. An employee watched Mae Garber shoot Olive Adkins from the front steps. *Author's collection.*

The fight between Mae Garber and Olive Adkins took place in this area along Selina Street in McCausland. *Author's collection.*

But rumor is not necessarily fact. People can whisper anything they want, whether what they are saying is true or not. Regardless of whose side they were on, many people in town signed a petition banning both William Funk and Mae Garber from Olive Adkins's funeral. They had probably had enough of the trouble caused by the relationship and perhaps felt that Adkins at least deserved a peaceful burial.

The county attorney charged Mae Garber with second-degree murder. The trial was to be held in November 1916. During that trial, many witnesses testified as to what they had seen that day. By and large, their testimony put Garber in a positive light, and at the conclusion of the trial, she was acquitted. It had once and for all been determined that the shooting had been done in self-defense and that Mae's actions were completely justified.

The little town moved on with life, as it always had. The peace and quiet so prevalent in the small town before the murder returned. What the residents thought of those involved with the crime was no longer relevant. The courts had found the former postmistress innocent, and besides, Mae Garber, her children and William Funk had all moved out of town, which helped the residents to forget about the events of the summer of 1916.

Although it was the decision of the court and the ultimate opinion of the townspeople that Mae Garber did not willfully intend to kill Olive Adkins, there were still many witnesses who had seen Mae and William together. This included seeing them at Garber's home. Could they have had a secret relationship that they did not want to talk about? Had William, fed up with Olive's addictions, sought love elsewhere and found it with the postmistress?

There was no substantial proof of any of this, and once it was found that there had been no premeditation in the murder of Olive Adkins, none of the murders mattered anymore. Eventually, Garber and Funk both moved out of McCausland, first Funk and then Garber and her two children.

Sometime later, it was discovered that Funk had changed his name and moved back to Wisconsin. A short time later, Garber moved to the same town, where the two were married. In a letter to the *Davenport Democrat and Leader*, Funk explained that they had moved to a place where they were respected and, with new surroundings and a new name, they could start over.

Had there been something between them in Iowa, or had they fallen in love after events drove them closer together? Over one hundred years later, the truth behind that particular part of the matter will probably never be known. All that can be known for sure is that a woman, driven by her personal demons and by jealousy, attacked her rival, whom she blamed for stealing her precious mate, and was shot dead in self-defense on a long-ago summer day.

BLOOD DEBT

I t was cold that early February morning as the men set out for work. Many of them were originally from Armenia, a small country in Eastern Europe. Like so many had before them, these men were running from something bad in the old country, looking to capture a piece of the prosperity and peace that America had to offer or both. They had come, either directly or indirectly, to Bettendorf, Iowa. These men had found work in various positions within the Bettendorf Company, the economic powerhouse that served as the driving force for many things within the various communities of the city.

Although normally peaceful men who went to the shops, worked hard and then returned home after a long day, this morning the men were angry, incensed over a scene they had watched play out before their very eyes in front of the local boardinghouse. The workers had determined they were going to put an end to the grisly happenings going on there, and they began to make their way toward the perpetrator of the crime.

The man standing in the yard turned, faced them and raised his pistol toward them. He warned the workers not to come any closer. Cautious of the weapon, they stopped, watching the armed man warily. Without knowing, the group of Armenian men had inadvertently stumbled upon what was to become one of the most sensational crimes of 1921.

WHEN WILLIAM BETTENDORF HAD decided to settle in the rural town of Gilbert in 1902, he was looking for a fresh start. When he was in his early twenties, he had worked for a plow company in Peru, Illinois. A natural inventor, his keen mind had perceived a need among farmers. In the plows being manufactured at the plant, farmers, plowing a furrow across their farm field, would have to stop at the end of the row and physically lift the plow blade out of the row. Then, they would have to turn the plow around and lower the blade again in order to start the next row. Needless to say, this was very physically intensive and time consuming.

William designed and built a new plow that, by pulling a lever that activated a series of gears, would mechanically lift the plow out of the furrow. The farmer would then turn the plow around, pull the lever again and begin the next row, all without having to get off the plow. It saved a great deal of time and energy by taking the old design and making it more efficient for the end user.

The Peru Plow Company, the firm that William worked for, agreed to manufacture his new plow design. William held on to the patent, and his new invention became extremely popular around the country.

The next thing that William did was, putting it simply, redesign the wheel. The standard metal wheel of that era had several metal spokes that connected the metal rim to the hub of the wheel. The wire was simply welded into place on the surface of those areas. Unfortunately, this caused the welds to break and the spokes to fall out. Eventually, this would render the wheel useless. Bettendorf decided that by drilling holes in the hub and then attaching the spokes inside, it would make the wheel stronger. He was right. Once again, the firm he worked for agreed to manufacture it. It was even more popular than his plow had been. The Bettendorf Metal Wheel, as it came to be known, sold so well that the company changed its name to the Peru Plow and Wheel Company.

However, William and the company began to disagree on how the wheel should be manufactured and how to best meet the increasing demand for it. The two parties were unable to resolve their differences, so William set out on his own.

He came to Davenport, Iowa, with his younger brother, Joseph, and founded the Bettendorf Metal Wheel Company, close to the Mississippi River. The fledgling operation not only survived in the competitive industrial world but thrived. It was tremendously successful, and the factory itself grew until it became the largest in the entire city.

But in early 1902, tragedy struck. The factory suffered two devastating fires only a few months apart. Production was halted, and the future of the

company was called into question. If the company was going to continue, which William was determined it would, he would have to relocate.

Before the fires, William had received offers to relocate to the nearby city of East Moline, Illinois. And there was always the option of clearing out all the rubble and rebuilding directly in Davenport. While he was pondering the issue, William was approached by a friend, C.A. Ficke, who offered another option.

Ficke, a former Davenport mayor, owned some land in a small town just east of Davenport by the name of Gilbert. It was near the riverfront and offered a lot of room to expand. It was a great place for a fresh start. William and Ficke approached the town, which was excited about the idea of having such a large factory located right in town. A short time later, William started construction of his new Bettendorf Company plant there.

As he grew the factory, William made sure to grow the town as well. He put significant funds into developing local businesses and building new houses. He also built a hotel where traveling workers could stay until houses of their own could be built for them. As the citizens had taken care of him, William took care of them in turn.

The town, in gratitude, renamed the booming town Bettendorf, after its benefactor.

By 1905, business was positively booming for the Bettendorf Company. After the invention of the Bettendorf Truck, a newly designed railroad car truck invented by William, industry demands for it allowed William to focus solely on railroad car parts and stop manufacturing wagon pieces, including his famous metal wheel.

William died suddenly in 1910, and his younger brother Joseph took over. The factory continued on, growing in wealth and prosperity.

In 1914, a young Mexican by the name of David Macias came to Bettendorf. He had arrived on official business for the company he worked for but liked America so much that he decided to stay. He immediately found work at the Bettendorf Company and became its first Mexican worker. But he was not going to be its last.

About three years later, with World War I raging overseas, many of the workers at the factory had gone to fight alongside their countrymen on the battlefields of Europe. Joseph needed workers, and he turned to David for help. He asked the man to return to Mexico and recruit replacement men.

The younger man agreed and traveled to Juarez, Mexico, to find as many men as he could. He eventually returned, bringing with him dozens of eager

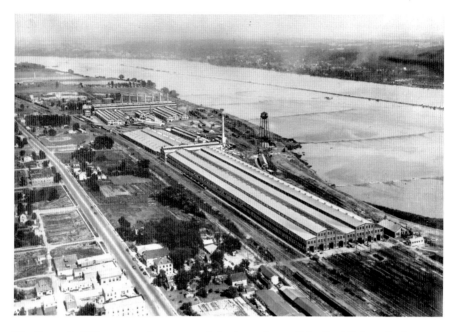

The Bettendorf Company, where many of the Armenians at John David's boardinghouse worked. *Courtesy of Davenport Public Library.*

workers. Mexicans, however, were not the only immigrants who found work at the Bettendorf Company.

Armenians had started to travel to the United States several years earlier, mostly due to the continuing hostilities between the countries of Armenia and Turkey. Problems continued within the region, and many grew tired of having to deal with it. So, like so many Western Europeans before them, they packed their belongings, gathered their families and made the trip to America. One of those was a man named John David.

John David had left Armenia in 1901 to flee the Turks. He eventually settled in Bettendorf, becoming one of the very first Armenians in the area. Over the next several years, John built trust in the surrounding community, especially with the work leadership of the Bettendorf Company. He helped bring other Armenians to the region and found them jobs working there.

Around 1911, John was able to bring over his wife. Together, they opened a boardinghouse at 418 East State Street, and it quickly became a popular place for Armenians to stay. The boardinghouse was only a relatively short distance away from the Bettendorf Company, putting the men within easy walking distance.

Although long since torn down, John David's boardinghouse was located in this location on State Street. *Author's collection.*

But more than that, the Armenians were staying with their fellow countrymen. They remembered the old country and understood the customs and traditions of their culture. It was a good place to be comfortable and make a new home, far from Turkish persecution.

John David became a respected leader within the community, earning him the affectionate nickname "King David." He loved his community and looked after them, and the Armenian community loved and respected him in return.

In 1913, an Armenian by the name of Arvid Helloian came to Bettendorf and began staying at the boardinghouse. Arvid changed his name somewhat, going by "Arvid Helloya" around town. He began working at the Bettendorf Company with his fellow Armenians. Arvid was friendly enough and got along well with everyone around him. He stayed out of trouble and worked hard.

One day in 1919, Arvid's friend and landlord, John David, approached him about a personal matter. John had run low on money, and he wanted to buy a cow and some bread to help feed his children. He did not want to see them starve, so he came to ask Arvid for a personal loan of $400.

John was a trusted friend and upstanding member of the community. He had helped Arvid get work in this new country right away and provided a place for him to stay. How could he possibly refuse? Arvid agreed to the loan with little hesitation.

John was elated. Now he could feed his children! He thanked Arvid profusely for his generosity, slapping him on the back and giving him a broad smile. John told his friend that he would pay him back the entire sum the following week. Arvid probably felt pretty good about himself right then. He had helped a friend who had helped so many.

The next week, John did not pay. Arvid, confident that his friend would follow through on his promise of repayment, casually asked him about the situation. John gave a quick apology and said that it would have to wait until the following week.

On and on this went. Arvid asked, John David responded that payment would come next week. Two years later, in 1921, he still had not repaid his debt.

Arvid, for the most part, let the matter slide. Sure, he was irritated about it, because $400 was a lot of money. It had not been a casual loan, and while it may not have been enough to buy one of those fancy homes on the bluff overlooking the Mississippi River, it was still a significant sum to him. He would not simply let the matter slide away and be forgotten.

Yet still, he did not need the money that badly. He liked John well enough, and he could stand to wait. Arvid would play this cute, yet annoying, little game for a while. There was no need to rush. But all that changed when Helloian began to receive letters from his uncle in Armenia. The letters explained that Turks had been raiding the town where Arvid had grown up. Both of his parents had been killed, and his two younger brothers had been kidnapped and taken back to Turkey. Later, Russians came and took the boys from their original Turkish captors and, instead of setting them free, kept them imprisoned. The uncle begged Arvid to come back home and rescue his lost siblings.

How could Arvid refuse? He liked his new life and was happy here. But family was still family. There was no question in his mind—he had to go back to Armenia.

As quickly as he could, Arvid began to make preparations to return. He was able to take care of many things almost straight away, including withdrawing all of his money from the bank. However, there remained one major task to be completed: it was time to call in his debt. The game that he and John David had been playing for so long had to end.

Arvid went to his friend and, as he had so many times before, asked for his $400. Predictably, John replied that he would pay him later. The old frustrations set in. While before he could push it off to a corner of his mind, Arvid now had a reason to have that money back. He explained the situation to John, but it did not matter. The answer was the same.

Over the next several days, this same routine was played out, with the only difference being Arvid's rising frustrations. He had to get back to Armenia. He had to take care of his family. John David was being stubborn, and it needed to stop.

Unbeknownst to Arvid, John had already begun to take steps to repay his debt. He did understand that his friend needed to leave. But John did not have $400 lying around; otherwise, he might have simply paid the debt and been done with the entire situation. Running a boardinghouse and having four mouths to feed is not always cheap. But a debt is still there, no matter how long you put off paying it.

John went to his attorney, William Scott, about the issue. John's goal was not to get out of the debt but, rather, to seek the lawyer's assistance in selling some of his property in Bettendorf. He told Scott that he was going to use the proceeds of the sale to pay off his debt and settle with Arvid.

On the morning of February 2, 1921, Arvid awoke, stretched and went to wash his hands. As he approached the sink, he overheard John talking with another boarder, Mike Astorian, in the kitchen. They were talking about him. John was explaining to Mike that he was not going to pay the debt he owed, not one red cent.

Arvid could not believe it. He had given that money on good faith and had waited for two years to receive payment from his friend. He had been patient and forgiving. He had been a good friend! But now, when Arvid needed it the most, John was not going to pay it back? How could he do that?

All the frustration that had built up in him over the years began to curdle within his soul. The frustration turned bitter and started an angry fire within him. Arvid began to walk back to his room, and as he did, the fire grew, turning into a white-hot rage. How could John David not pay him back?

Arvid opened the door to his room, seething. He crossed over to his old trunk and opened the lid. With one hand, he began to search around inside until he found what he was looking for: an automatic pistol. Arvid took it out, put it in his pocket and started to walk back toward the kitchen. On the outside he was calm, but he was furious inside. Arvid Helloian was going to have his repayment, one way or another.

Before he knew it, he was standing in the doorway to the kitchen. The only thing that he cared about in that moment was John David. His vision narrowed, focusing until John was his entire world. He could feel the anger swell inside him. The cold steel of his automatic pistol felt good against the flesh of his hand. One last time, Arvid asked John David if he was going to repay the loan.

As he prepared his breakfast, John David knew nothing of the gun in Arvid's pocket. He understood that Arvid wanted to get back home, and he was finally taking steps toward paying the man back, even going so far as to sell property to get the money. But he told Helloian none of this. Maybe he was just tired of the constant, unrelenting badgering about paying the money back. Like so many people who are pestered by creditors, perhaps John had just reached the point that he did not care anymore and in his own frustration had carelessly said that he was never going to pay the loan, even though he had every intention of doing so.

But no matter what his intentions were, in that moment he made the fateful decision to tell Arvid Helloian that he was never going to pay back that $400.

A slap across the face could not have hit Arvid harder than those words. In that moment, the frustration and rage that had been burning inside him exploded like a bomb. Jerking the pistol out of his pocket, Arvid pointed his gun at John and fired.

The bullet struck the older man in the arm. Without hesitation, John David started across the room in an attempt to close the distance between himself and his attacker. As he reached for the gun, Arvid fired again, this time hitting John in the neck. The older man stopped, grabbing at the wound, blood flowing from it freely like a red river. The wound on his arm was bleeding, too, soaking his shirt. John, badly hurt, turned from Arvid and ran into the next room. Arvid pointed the gun at the fleeing man and pulled the trigger again, but nothing happened. With a snarl, he tried again, but still nothing.

Arvid looked at the gun and realized that it was jammed. He took a moment, cleared it and then started after John David again. Before he got too far, he felt someone grab his arm. Arvid turned to see another boarder, Kachig Moses, attempting to restrain him. Arvid raised his gun and pointed it at the man, saying that if Moses did not let him go, then Arvid would shoot him dead. Moses relaxed his grip a bit, and Arvid tore free from his grasp.

He ran out of the back door, unfazed by the cold winter morning. He knew that the only way John could go was through the front door, so Arvid went around the house and into the front yard.

Just about then, the front door opened. There was John David, still clutching at his neck, desperately trying to stop the blood oozing from his wound. He stumbled forward into the snow, delirious with pain and blood loss. Arvid raised his pistol again, this time taking careful aim at the man he had once called his friend. He fired once more and this time shot John directly though the eye. John stopped moving then and stood stock still. Without a sound, he fell straight onto the frozen ground.

Arvid must have known that John David was done for, but it was as if he could not stop himself. The anger and frustration that he carried with him were still howling in his soul, and the engine of destruction that it now powered could not fully stop until it had completely burned out.

Crossing to John's corpse, Arvid emptied his gun into the man's body. But for him, even that was not enough. Out of ammunition, he began to savagely and repeatedly kick John David's prostrate form. Then Arvid knelt down and began to smash him in the face with the butt of his gun, over and over again. He was taking out his fury then, giving those feelings full vent. Arvid's sole focus at that moment was to destroy John David.

As focused as he was, Arvid was completely unaware of the group of Armenian men now walking past the house on their way to work at the Bettendorf Company. They stared at Arvid, a man they had worked with and lived alongside, horrified by what he was doing.

Just then, Arvid started to come back to himself. He looked up and saw the group of men and the stunned looks on their faces. A few of them had started moving toward him in order to halt his attack on John David. Thinking quickly, Arvid pointed the gun at them, ordering the men to stay back. The workmen did as they were told. The gun in Arvid's hand was empty, but they did not know that. And why take chances with someone who had apparently already killed one person?

Arvid backed away slowly from the crowd. Step after careful step, he moved backward until his heel clicked against the wooden threshold of the front door. He took a chance and turned his back to the crowd. For a split second, he expected to be grabbed or hit from behind, but it never happened. Arvid went into the house and quickly locked the door.

He made his way to his room, where he put his automatic weapon in his trunk and then grabbed another gun that he owned, a revolver. Just as he had before, he put the gun in his pocket and went back downstairs.

Meanwhile, the crowd of Armenian workmen had called the authorities as soon as they were able. The first to arrive was Bettendorf marshal John Kracht. Someone told him that Arvid Helloian had killed John David and

then had locked himself inside the house. Kracht quickly positioned men all around the outside of the boardinghouse, blocking all exits. Arvid was now trapped and had nowhere to run.

Soon enough, other members of law enforcement also began to arrive at the scene. Knowing that Arvid was still in the house, two Davenport policemen went inside, where they began to search for him. They found Arvid preparing to escape but quickly stopped him and placed him under arrest. Helloian did not complain or resist.

He was taken to the Davenport police station, where he was questioned about the murder. Arvid readily confessed to the murder, telling the police every detail as he recalled it. He was their man and was not ashamed of what he had done. After answering all questions posed to him, Arvid was led back to his cell to await the coroner's inquest.

Back at the boardinghouse, John David's family was left to pick up the pieces. His wife had been left a widow with three young children to raise by herself. She had seen what had happened to her husband with her own eyes that morning. She had been woken up by gunshots and had made her way outside just in time to watch Helloian kill her beloved husband.

She was beside herself with grief. Even though her children tried to comfort her the best way they knew how, John's wife finally had to be sedated by a doctor. Later, she received another blow.

Some relatives began to look into John David's monetary situation. They discovered that he did not have much money at all, despite having the boardinghouse and owning property in Bettendorf. It became a definite concern as to whether his estate could actually pay for his funeral. Those fears were short-lived, however. The money was found for a funeral, and John David was laid to rest in Oakdale Cemetery in Davenport.

The coroner's inquest was held on February 3, 1921, at the Bettendorf Town Hall. The room was packed with members of the Armenian community. The proceedings began when a manacled Arvid Helloian made his way through a crowd of nearly one hundred people. The police were afraid that the assembled Armenians, who thought so much of John David, would hurt or even kill his murderer. But the Armenians kept their peace and held their tongues.

Just as J.D. Cantwell, the Scott County coroner, was about to have his first witness of the evening stand and deliver his testimony, Arvid suddenly asked if he could make a statement. Cantwell immediately cautioned him that he did not have to say anything that he did not want to, giving Arvid one last chance to sit back down and stay quiet.

But Arvid was eager to share his side of what had happened. After being sworn in as an official witness, Helloian was allowed to begin his story. He recalled how he had given the loan to John David and how repayment was always put off. Arvid explained that he wanted to return to Armenia and visit his family there. Then, in front of nearly one hundred other Armenians, not to mention the Scott County sheriff and coroner, Arvid freely admitted that he had murdered John David. When he had finished speaking his piece, he simply resumed his seat next to the sheriff and quietly observed the rest of the proceedings. Arvid was returned to the Scott County Jail after the inquest to await trial.

John Weir, the Scott County attorney, filed a charge of first-degree murder. Arvid, in turn, entered a plea of "not guilty."

To pass the time between the preliminary hearing and the trail itself, Arvid sang in the jail. Much of what he sang was Armenian folk tunes and lullabies. He would sit, smiling, and sing, tapping his foot to the rhythm. Not once did Arvid express regret for his crime either to his jailers or his fellow inmates. While he sang in the jailhouse, his lawyers worked to build a defense for him.

In early May 1921, Arvid Helloian was placed on trial for the murder of John David. While his defense attorneys did their work, John Weir sought not only to convict Arvid of first-degree murder but also to convince the jury to give him the death penalty.

Along with several other witnesses, Helloian himself was asked to take the witness stand. Through expert questioning by his defense attorneys, Arvid explained how he had given John David the $400 loan and how he wanted it repaid after his uncle began to urge him to return home for the sake of his brothers. And, once again, he freely and openly confessed that he had killed John David.

Finally, after all the witnesses had given their testimony and evidence was considered, the defense attorneys and the county prosecutor gave their closing arguments. The judge explained to the twelve jurors assembled that morning the various verdict selections that they could vote on, ranging from full acquittal to the death penalty. The judge also explained what each choice meant. They were excused from the courtroom, and their decision-making process began.

The jury wrestled with its decision for nine hours, considering the evidence and the various testimonies. At about nine o'clock that night, the jury members gave their decision: manslaughter. Helloian's story of his dead parents and needing to return to Armenia to rescue his brothers in prison had helped sway them.

John Weir was shocked. He openly stated that, given the strong case and evidence presented, Arvid Helloian should have at least been sent to prison for second-degree murder. But his opinion no longer mattered. The jury had decided, and its verdict was upheld. Helloian was sentenced to serve eight years at the state penitentiary in Fort Madison, Iowa. He was also ordered to pay a fine of $1,000, which would either be paid in cash or in time served, even if he had to stay in prison longer than the allotted eight years.

Ultimately, it did not matter what everyone thought of the verdict of the case. John David was still dead. Helloian, wanting so desperately to get his money back from his friend so that he could return to Armenia and take care of his brothers, got neither. Instead, he was going to spend the next several years in prison and pay more money back to the state than the $400 that he had killed for.

In the end, everyone lost the moment a heated conversation turned into murder on a snowy February morning in 1921.

THE LONG GROVE BANK ROBBERY OF 1921

Harry Hamilton and Roy Purple looked at the two bank employees. Harry had roughed up the old man pretty good; he knew his place in the pecking order now. The young girl was terrified. They had done their absolute best to keep her calm and reassure her that things would be all right, but she was still afraid. And who could blame her? They were tough men taking what they needed.

Hamilton looked at Purple, his face serious. He had taken his time and planned this heist correctly this time. Except for a minor problem at the outset, everything had gone smoothly. Purple gave a little smile and gripped the small black bag a little tighter. The revolver in his other hand made him feel strong. Giving a quick nod to his partner, he opened the door and started down the stone stairs just outside, his eyes scanning his surroundings as he went.

Suddenly, Purple stopped. Harry's eyebrows knitted together in an expression of puzzled concern. Without warning, Purple pointed his gun and began firing at something, then broke and ran.

Fully alert now, Harry tried to see what Roy had been shooting at. Inwardly, he groaned. Why did everything always have to end up going so badly?

HARRY HAMILTON HAD NOT been born in Iowa. His life journey had begun in Niagara Falls, New York, in 1881. As time passed and Harry grew older, his

choices led him to live in Davenport, Iowa. He needed a job, so he decided to become a police officer.

Policemen, by the very nature and definition of their profession, are drawn into close contact with criminals, both amateur and professional. Some officers are paragons of virtue, driven to help people in need and serve their community. Others, like individuals in so many other professions, are just doing a job. They clock in, do what they have to do and go home to their families. Unfortunately, there are also those who cross that line and become very much like the criminals they are sworn to protect us against.

All these decades later, it is hard to determine what effect the job had on Harry Hamilton, if any at all. Maybe he was a good policeman, maybe he was not. For whatever reason, he quit law enforcement and decided to enter into a new profession, one that had him working in tandem with some of the most notorious criminals of the region at that time. He agreed to be an editor for the *Rock Island News* in nearby Rock Island, Illinois.

Started in 1905 by local crime kingpin John Looney, the *Rock Island News* was notoriously corrupt. Looney had started the paper primarily to use as a weapon against the *Rock Island Argus*, one of the most upstanding newspapers of the city, in retaliation for a perceived slight against him. Not known for turning the other cheek, Looney was determined to ruin the paper's reputation. But this was not the only purpose of the *News*.

Looney, being an enterprising man, also made use of the *News* for blackmail. He did not care whether the things published in his newspaper were true or not, just as long as they served a purpose. Outlandish articles were written about people with money, potentially ruinous things that could destroy careers if they were ever made public. Even if a powerful individual never did what he was being accused of, the accusation alone could be enough to permanently damage his reputation.

Once the article was prepared, Looney or one of his people would approach an individual, show him the said newspaper piece and threaten to publish it. However, if that individual wanted to pay a fee to Looney to make sure the article never appeared in the paper, then it would never be seen.

While Looney was living on a ranch in New Mexico, Dan Drost, the publisher of the *News* and one of Looney's trusted associates in the criminal underworld, convinced him to hire Hamilton as the editor for the *Rock Island News*. Looney agreed, and Hamilton started the job. Most people knew the kind of man that John Looney was, as well as the kind of men who worked for him. Hamilton, having been a police officer, probably had absolutely no illusions about who he was working for or what he would be asked to do.

Hamilton had no issues telling lies in the paper. He managed the slurs printed on the pages of the *Rock Island News* and made sure the vile words were spread far and wide. Having been a policeman, Hamilton also had a firm sense of his surroundings and what was in them. He noticed things. Certain details came to his well-trained eyes, such as the fact that Dan Drost could hardly read or write. The job was steady and it put food on the table though, so he carried on, simply filing away some of his observations in the back of his mind.

Eventually, Hamilton's lying caught up with him. He was arrested on charges of criminal libel and sent to serve a year-long sentence in prison. After being there for ten months, prosecutors approached Hamilton about testifying against his former boss, Dan Drost. Hamilton readily agreed and turned state's evidence against Looney's lieutenant in exchange for a shortened sentence.

Released in 1920, it did not take Hamilton long to get in trouble with the law again. This time, it was for his part in the burglary of a general store in Wheatland, Iowa. Hamilton was arrested and questioned about his partners. Stubbornly, he refused to give authorities any names.

Once again, he was convicted and sent back to jail, this time to serve a ten-year sentence. Luckily for Hamilton, fortune smiled on him, and he was released from prison after spending only a short time there in late 1921, and the free air never smelled sweeter. He gathered up what belongings he had and returned to Davenport.

Unfortunately for him, Davenport was experiencing an economic downturn. Jobs were scarce, and there were many people who could not find employment. Harry soon found himself joining their ranks. It probably did not help him much that he was a twice-convicted criminal, fresh from a jail cell. What jobs he did find were in the realm of short-lived manual labor. The temptation to return to a criminal lifestyle must have been tremendous at that point. Hamilton, stubborn as ever, refused. He told several people that he was going to be an honest, upstanding citizen. But even his prodigious stubbornness had its limits.

By the end of November, Hamilton was getting desperate. It was all well and good to be honest, but when you could not find work and were looking poverty straight in the eye, it was a little harder to be noble. Desperation gnawed at his resolute refusal to return to his criminal lifestyle, gradually weakening his resolve. He kept struggling for a bit, but finally, it all became too much for him. Once again, Harry Hamilton decided to give up being noble and to return to the life of crime that he was so familiar with.

As Hamilton stood at the doorway of the bank, trying to see what Roy Purple was shooting at, these thoughts were probably far from his mind. The decision had been made, and the robbery had been committed. Foremost in his thoughts must have been getting away clean, and his partner firing at some unseen threat had almost surely ruined any hope of that.

Once the trigger has been pulled, it is hard to get that fired bullet back into the gun. Maybe, in that last split second, Harry hoped that Purple had just been trying to scare some bystanders, to get them to duck down and look away before the two of them drove away.

Those hopes were dashed when he heard several dozen gunshots answer Purple's own. The sound was almost overwhelming, the quiet of the small midwestern town shattered by the sharp reports of pistols and rifles and the deep bass booming of shotguns. Harry heard the bullets ricocheting against the side of the stone building and the sound of glass breaking.

He did not want to, but Harry had to go into the storm of lead outside. He had to get away. He did not want to go back to jail. He wanted to take that money and make another try at being honest. Maybe this time he could get it right. Taking a deep breath, he steeled himself as best as he could and ran out the door and into the waiting gunfire.

When Hamilton had finally given in and made the decision to make fast cash in a criminal way, he began to plan. No matter what criminal enterprise he had ever engaged in, they had always had a plan. Maybe not a good plan, but a plan nonetheless. There was simple strategy in the slander and blackmail at the *Rock Island News*, and there had even been a plan when he and his associates had robbed the general store in Wheatland. Unfortunately for Harry, neither plan had worked out in his favor. But his time, he was going to make his own plan, form his own strategy. This time, Harry Hamilton would make some fast cash and make a clean getaway. He needed money right away, so he wasted no time in getting to work.

His first decision was probably to figure out what he was going to do. After some deliberation, Hamilton decided to rob a bank. A bank was a place with a lot of cash, and he had already had some experience with burglary. In addition to this, it is quite possible that Hamilton had picked up some pointers from a few of his fellow prison inmates who had committed successful robberies in the past and decided to put some of that knowledge to use. Regardless of the reason, Hamilton made his decision. Once that had been done, everything else began to fall into place.

Hamilton needed a partner, so he approached a Davenport man, Roy Purple, about helping him. Roy worked as a barber and had a wife and twin sons at home. The boys were only a year old, and children that young need a lot of care. That care always seems to also require a lot of money. That alone might have given him reason enough to help with the heist, but for Purple, it was not the only reason.

Purple liked to associate with the criminal element. At one time, Purple had been arrested by Davenport police as a suspect in a major robbery where hundreds of dollars of merchandise had been stolen. Try as they might, the police could not gather enough evidence to convict the barber, so he was released. Whether he had actually taken part in that theft was beside the point. By the end of 1921, Purple was willing and eager to assist Harry Hamilton in any way that he could.

For reasons that will forever remain their own, the two men decided to rob the Stockman's Savings Bank in Long Grove, Iowa. Perhaps they thought they would have less of a chance of being seen and recognized by someone who knew them. Hamilton, who was a former newspaper editor and ex-convict known to police, might easily be identified by a former associate or someone who had seen his picture in the *Rock Island News*. Many men had sat in Roy Purple's barber chair, so if they robbed a bank within the city of Davenport itself, someone might remember him. Besides, even if they made a clean getaway, if law enforcement knew who they were, they could simply come to their homes and place them under arrest.

It is also possible that Hamilton and Purple thought that it would be an easier score. Long Grove was a small town almost twenty miles north of Davenport. It was a very rural area, focused mainly on agriculture. There was no police force there, so the bank would have to rely on help from Davenport.

Another idea is that the two robbers might have picked Long Grove because, being a small town unused to major crimes, a sudden act of violence would catch residents off guard, giving Hamilton and Purple an advantage. Ultimately, their reasons would remain their own. They had picked their target and moved forward to the next step of their planning.

One of the essentials for simple bank robbery success has always been speed. A robber gets in fast, takes everything fast and gets away with the cash fast. In order to accomplish this, Hamilton and Purple had to know where they were going and what exactly they would be facing inside the bank.

To accomplish this, Hamilton decided that they needed to get inside the bank before the robbery and take a look around. The robbers picked a day

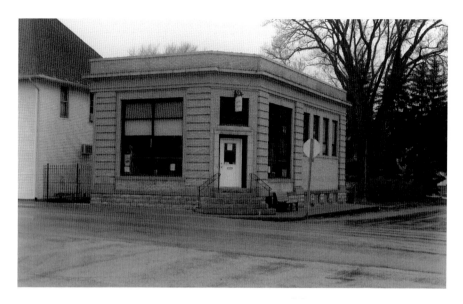

The former Stockman's Savings Bank in Long Grove, Iowa. *Author's collection.*

and traveled north to Long Grove. Hamilton went inside the bank on the pretense of cashing a twenty-dollar bill. While the cashier took care of him at the teller window, Hamilton was looking around, taking mental notes of everything that he saw.

While he was busy sizing up the bank, the bank president, R.K. Brownlie, was sizing up Hamilton. Born and raised in Long Grove, Brownlie was descended from some of the first people to settle the town and make it into what it was by 1921. Now a little over seventy years old, he had more than lived up to his family's legacy by dedicating himself to serving both his family and his community.

Brownlie was intelligent and shrewd, and there was something about Hamilton that caught his eye. Although probably not recognizing him from anywhere else, Brownlie did take note of what Hamilton looked like in the bank that day. He probably was not overly suspicious of him at that time, as he had no reason to be. The man was just cashing a bill. But there was still something about the man that made Brownlie remember him.

The trip to Long Grove from Davenport also gave Hamilton an opportunity to examine the route that he and Purple would take to and from the bank. A wrong turn could either be an inconvenience or spell out disaster for their endeavors. The route they chose was very straightforward, running north from Davenport, though the town of Eldridge, Iowa,

a few miles south of Long Grove, and then through Long Grove itself. Conveniently, the bank sat right on that road, with side streets heading off that. It would be easy to maneuver in the junction outside the bank, as well as park the car for a fast getaway.

Like everything else in their plan, the robbers wanted their car to be fast. The robbers began looking around Davenport, and soon they found a car that they felt suited their needs. At the garage of Hugo Brandt, a local mechanic, they found a Hudson Touring Car for sale.

In the 1920s, Hudson was one of the top automobile manufacturers in the United States, just after Chevrolet and Ford. It had invented a very powerful six-cylinder engine it had dubbed the Hudson Six, which put its cars in a top-tier speed bracket for the time. What more could two bank robbers looking for a fast car want? Almost without hesitation, they bought the car, probably a little proud of their purchase.

Now that they had their route planned, the bank layout mapped out and a fast car, the next step for the robbers was to think about the final part of their getaway. While masks could obscure their features and be gotten rid of as soon as the robbery was finished, the bank personnel and whoever else would be able to identify their clothing. The robbers' solution for this was to hide a change of clothing along a road leading out of Davenport. The clothing only consisted of different coats and hats for the men, to keep the change as fast as possible. Hamilton and Purple hid them in a culvert so they would lay relatively undisturbed until after the robbery.

Finally, they were ready. Their chosen day was December 15, 1921. They would drive to Long Grove and hit the bank right at the noon hour, then be gone before anyone really knew what was going on.

That morning, Purple said goodbye to his family and walked out the front door of his home in Davenport. A few hours later, he called his wife, Edith, and told her that he would be home that afternoon at around one o'clock. Perhaps, at that moment, Purple had dreams of returning home to his wife with handfuls of cash. But first, he and Hamilton had to go to Long Grove.

As they drove north from Davenport that morning, Hamilton and Purple were probably a little nervous. They had planned and prepared, but something could always go wrong. Hamilton knew this better than anyone. The *Rock Island News* had been a good job and then went sour fast. The burglary in Wheatland had also gone well but went bad even faster. This time, though, at Long Grove, everything was going to be all right. It was all going to be okay.

Purple had already had a very close brush with going to prison when the police had questioned him about that big robbery in Davenport. Whether he was actually involved or not, being called in and interrogated must have been a harrowing experience. But Purple had gotten away with it. There had not been enough evidence. Success builds confidence, and Roy had successfully gotten out of doing any prison time or any further prosecution from curious law enforcement officials. It was going to be the same with Long Grove.

But, confident and self-assured as the two men were, they must have had some kind of nagging doubt or performance anxiety. Hamilton had already done time in prison, and Purple did not want to go there. To steady their nerves, the two men fortified themselves with alcohol, taking turns drinking from a beer bottle as they plodded toward the Stockman's Savings Bank.

As they drew closer, the pressure must have intensified. Their hearts beat a little faster; their focus narrowed a shade more than usual. Hamilton and Purple were thinking of the robbery now. They knew what their goal was, but the two were probably more interested in executing their plan correctly and getting their cash rather than how they were going to spend it. The robbers would take one step at a time, and as they crested the hill by the Long Grove Christian Church a few blocks away from the bank, they were about to take their first step.

The big Hudson Six picked up speed as it hurtled toward the crossroads by the bank. There were people around, but Hamilton and Purple had already pulled handkerchiefs over the lower halves of their faces to help hide their identity. The two could see the bank now, standing stoically on the corner in the very heart of the small town. And then they were there. Slamming the car to a sudden stop in front of the bank, Hamilton and Purple, with masks on their faces and pistols taken from the car in their hands, burst out of the car and ran toward the stone steps going up to the door. Their focus was razor-sharp now, their minds in the moment.

One of them reached out and grabbed the door knob. He turned the handle, pushed hard…and nothing. The door held fast. The robber tried again, harder now. The knob would not turn and the door would not give. It was locked tight.

The two men were mentally off balance now. This was not part of the plan. They were supposed to be inside, shouting commands and grabbing cash. Hamilton and Purple looked at each other, trying to figure out what to do. Confusion began to cloud their minds. The alcohol, which had just a short time ago served to calm their nerves, now slowed their thoughts even further.

Eventually, their heads began to clear. As the adrenaline coursing through their systems began to dissipate, the robbers gradually became more aware of people looking at them. Their perfect plan had just gone wrong. With all those people staring at them, they had to make a decision before someone approached them.

Thinking quickly, Hamilton and Purple got back in their car and started to drive. They did not want those people to get too good a look at them, and it was futile to try to get into the bank right now. A short distance away, one of them took the bottle of alcohol they had been drinking and threw it out the window.

Once again, things had not worked out exactly as Hamilton thought they would. But he could improvise. He would drive around for a little while, let his head clear and then figure things out.

Hamilton was perturbed. This was supposed to be easy. Well, if not easy, then at least smooth. He and Purple had prepared and planned. It all should have gone well. They should have been back in Davenport, deciding how best to spend their money. But as it always had been in his criminal career, something had to go wrong.

Driving the big car, he circled the town two or three times, gathering his thoughts. The robbers, probably conferring about what to do next, decided to drive away for a while and wait for the bank to open. There were too many people coming out on the street now, too many people to get in the way and identify them. They drove away into the countryside to calm their nerves, let the adrenaline die down a little and wait to try again.

Back in Long Grove, people were amazed. In the middle of the business district of town, in broad daylight, someone had tried to rob the bank!

At Murray's Barber Shop on the opposite corner of the bank, Fred Murray had watched the men try the door. Dick Nagel, another local man, had seen the two men as they ran out of their car, holding pistols. Thinking on it, Nagel thought that one of them, Roy Purple, seemed familiar to him. He was not worried about them gaining entry to the bank because the bank workers always went to lunch at noon and locked the door. People at the hotel across the road to the east had seen the men, too. Everyone was surprised, puzzled and a little concerned.

Long Grove was not that big of a town, with only a little over 155 residents. In a small town, big news travels fast. One person told another, and then another. Soon, most of the residents had heard about the attempted bank robbery. One young man even took it upon himself to run a circuit around the entire town of Long Grove, sharing the news with whomever he met.

A local grain merchant, E.H. Anschultz, laughed when he heard the news. He did not believe a word of it, thinking that it was nonsense. The messenger who told him quickly moved on, leaving Anschultz to ponder what he had heard. No matter which way he looked at it, he would not believe that robbers had been in town. But he knew the bank president, R.K. Brownlie. Anschultz decided that Brownlie might know what was going on, so he set off across town to visit his friend at the Stockman's Savings Bank. He would discover the truth behind all this nonsense.

Archie Henne, a Long Grove resident, heard the news and began walking to Murray's Barber Shop to find out what all the fuss was about. Had someone really just tried to rob the bank?

Peter Willer, who owned another garage in town, saw Purple and Hamilton try the door and drive off. He also watched them toss the bottle out the window. Once they were a safe distance away, he curiously approached the bottle. Willer smelled it and knew immediately that it was alcohol.

Al Klindt, who owned a blacksmith shop and garage across the street, was also interested in what had happened. He waited for R.K. Brownlie and his bookkeeper, Jean Marti, to return from their lunch break and then immediately approached them with the news. Not having heard about the attempted robbery, the trio went inside to discuss it further. Soon after, E.H. Anschultz arrived and joined the group.

Klindt, in addition to several others about town who saw or heard about the robbers at the bank, were not just idly curious. They had a special interest in the crime because they were members of the Long Grove Vigilance Committee.

After a drastic upsurge in bank-related crimes in Iowa during 1920, the Iowa Banking Association determined that it needed stricter and more efficient methods of protecting the assets of its customers. For many years, the association had provided a certain amount of security for its member banks. This included protection against forgeries, theft and fraud. These services were provided by the Burns Detective Agency, known nationwide for its security services. While the group was, for the most part, reliable and performed well for the association, its agents were limited in number and could not be everywhere across the state.

After nearly a dozen robberies and burglaries during 1920, the Iowa Banking Association decided that it was time for a change. After some consideration, a plan was decided on. In conjunction with and permission from the State of Iowa, the association began to form what it called vigilance committees. For each member bank under the Iowa Banking Association, at

least four men would be chosen to form a vigilance committee. These men were deputized by their county sheriff with the duty to prevent robberies and burglaries at their local bank, up to and including the use of deadly force. To aid in this, the committee members were armed and provided ammunition for the task, if the need should ever arise. In Long Grove, this duty fell, in part, to Al Klindt.

While the news traveled, the bank personnel returned to the bank, unaware of what had happened. As they started to go about their usual business inside, E.H. Anschultz and Al Klindt came walking in. Brownlie and Marti were filled in on the events of the noon hour. When they heard, they were both alarmed by the news.

Anschultz kept giving his friend a hard time about it, still not believing that anything had really transpired. As they spoke, the big Hudson that everyone now knew to be the robbers' car came roaring past the window.

Alarmed, Jean Marti asked Brownlie what they were going to do. Brownlie told her that there was nothing that they could do and prepared to receive the coming thieves.

Outside, the robbers knew it was time. Hamilton and Purple had waited for the bank to open. They had to change their plans, true, but the goal was still the same. And after so much work, they were going to achieve it. Nothing was going to stop them now that they had come so far.

Driving fast, the Hudson sped past the bank building and slammed to a halt only a very short distance away, facing south. Hamilton parked the car this way so that when they were done inside, he and Purple could run back to their car and drive straight toward Davenport.

Once again, they scrambled out of the car, with Purple holding the black loot bag and both of them with pistols. Their adrenaline began to pump once more, and the alcohol they had consumed still drifted through their blood, dulling their nervousness. They ran up to the door, tried it—it was open. Success was nearly theirs! In their excitement, the two had forgotten to put their masks on again, but they did not care.

Running inside, Hamilton and Purple brandished their guns at the four people inside and screamed at them to put their hands in the air. Two of them, an old man and a younger one, walked right past them and out the door. For whatever reason, Hamilton and Purple did not stop them and allowed them to go. After having been there a short time before, perhaps Hamilton was only focused on the people he recognized as bank workers. Also, having fewer people there made the situation easier for the two of them to control.

Whatever the reason, the robbers had what they wanted now: access to a quick and easy score. The robbers forced the bank workers back into Brownlie's private office, where they demanded to know where all the money in the bank was. Purple repeatedly struck Brownlie, pounding on his head with his fist.

Hamilton and Purple took Brownlie out into the main part of the bank, leaving Marti in the office. Once again, they demanded to know where all the money was. Brownlie gave them the information they desired, and as they were told, Purple would quickly and eagerly stuff the money into his bag. They took everything they could—cash, securities and whatever else was available.

During all this, Hamilton and Purple kept asking the bank workers if they recognized them. Brownlie remembered Hamilton from his previous visit to the bank, when the robber had come in and cashed his twenty-dollar bill. But thinking that it would go over better with the already violent criminal, he lied and gave every assurance that he had never seen Hamilton before in his life.

In contrast to the bank president, Hamilton and Purple treated Marti very well, in light of the circumstances. Although they kept asking her if she recognized them or knew who they were, they also kept reassuring her. The robbers could tell Marti was scared, so they kept telling the young woman that she would be okay, that they were not going to hurt her. They also never struck her, unlike Brownlie.

In addition to asking if the bank workers recognized them, Hamilton and Purple sprinkled their questioning with threats. Brownlie and Marti were warned to never come to Cedar Rapids and told that if they ever told anyone anything about the robbers, then Hamilton's friends from Oskaloosa would come up and kill them. Marti did not really believe the robbers' threats and thought that the criminals were just trying to make them think they were from someplace else.

Once they were satisfied they had everything in the main part of the bank, the robbers forced Brownlie into the vault. As they shoved him in, the old man shuffled across one part of the carpet inside. Suddenly, Hamilton was furious. He turned on Brownlie, screaming at him, asking if he had set off a secret alarm. Brownlie told him that he had not and that there was not even such a device in the bank.

Satisfied but still nervous, the robbers picked up speed, eager to take their loot and leave. But in spite of this, they still were not sure if the old man had told them where everything was. Going into the office, they retrieved

Marti and brought her into the vault, asking her if there was more money somewhere. Sure enough, there was. Purple quickly swept it into his bag.

Finally, the robbers believed they had stolen everything that the bank had to offer. It was time for them to leave. With the two bank workers in the vault, Hamilton and Purple closed the inner doors. As they tried to close the outer door, however, Brownlie and Marti pleaded with the robbers not to lock them in, as it was a time-lock door. Time-lock doors were specially designed to help prevent robberies. Vaults equipped with these style of doors could only be opened at certain times of the day, and then only with the correct combination. So, if a would-be thief had the combination to the safe, he could not simply sneak into the bank in the middle of the night, open the vault and make off with his ill-gotten gains. Thieves now had to have both the combination and to know the correct time to open the door. Brownlie and Marti knew that if they were locked inside, then it would be several hours until the vault door could be opened. And so they begged Hamilton and Purple not to close the door. Mercifully, the robbers complied, satisfied that the inner doors would be enough.

Turning, they prepared to escape. Purple went first, with Hamilton waiting a moment. He heard Purple fire his pistol before the world exploded with the sound of gunfire answering those first shots. Taking a deep breath, Hamilton ran out the door himself.

The air was alive with bullets as he ran down the steps. Get to the car, he thought. It was only a short distance away. He could make it!

Gunfire filled the air, punctuated by the sounds of bullets striking the buildings around him. He fired his own pistol back randomly, seeking more to distract his attackers and force them back under cover than to actually hit anyone. Hamilton was focused on the car. He had to get to the car!

On some level, Hamilton probably took note of the prone body of his partner, Roy Purple, lying on the sidewalk as he ran, the black bag containing all their money beside him. But there was no time for that now. The only thing that mattered was getting to the waiting car, a welcome shelter from the hail of lead pelting down all around him. At that moment, survival was more important than money.

Suddenly, he felt a pain in his side, and then another. Then another burning pain started in his lower neck and another erupted in his arm. But still Hamilton ran. He was at the car now, running around to the driver's side door. As he did, he felt something strike him in the stomach, but the adrenaline and alcohol had probably dulled his nerves to some extent, and it did not even slow him down.

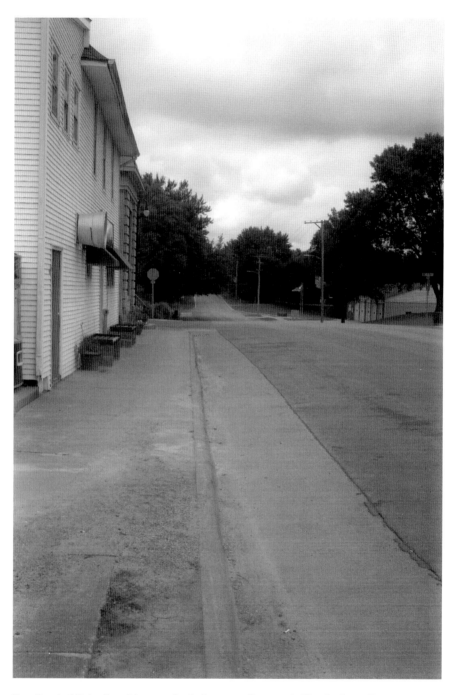

Roy Purple fell dead on this spot after being mortally wounded by the Long Grove Vigilance Committee in 1921. *Author's collection.*

Jerking open the car door, Hamilton lunged inside. Slamming the door, he hit the accelerator. The car did nothing.

Hamilton was shocked. They had deliberately left the car running so they could just jump in and drive away. He hit the accelerator again, ramming it all the way to the floor. Still nothing!

Before he could react, there were men with guns all around the car. Hamilton looked at them in surprise. How had all of this suddenly gone so wrong?

When Harry Hamilton and Roy Purple had come thundering into the Stockman's Savings Bank, Al Klindt and E.H. Anschultz had gone out the front door.

The two locals were probably surprised that the robbers had not stopped them, but they did not stop to think about that. They had a job to do. Anschultz went his way, and Klindt went to find another local and vigilance committee member, Dick Tobin. It did not take long. The two men armed themselves and then went into the building that the robbers had parked next to. They climbed the stairs and took up shooting positions in the upstairs windows, looking down at the getaway car and the robbers' escape route. Klindt wanted the robbers to actually commit the crime so that they were sure of the men's intentions.

Another man, Elmer Moore, placed himself behind a telephone pole north of the bank, with a direct line of sight to the front door. Other men, like Peter Willer, had also armed themselves and taken up similar firing positions all around the bank.

When Hamilton and Purple had first arrived in town and tried to rob the bank, the president of the Eldridge Savings Bank, M.H. Calderwood, had been notified. He was notified again when they reentered town and then again when they were actually in the bank committing the robbery. Eldridge was the next town over, so the vigilance committee of that town was alerted. Its members quickly armed themselves and made themselves ready, just in case the robbers in Long Grove decided to bring more trouble in their direction. Eight armed men, four in a car and four more at various hidden positions, waited for the robbers along the road between Long Grove and Eldridge.

Archie Henne, who had come to find out what the commotion was around the town earlier, reached the barbershop as the robbers were inside the bank. As he went in, he asked the patrons of the barbershop if there was any truth

to the news of a robbery. They confirmed there was, telling Henne that the robbers were still inside the bank. Someone then pointed out Hamilton's car, still running outside. Henne nodded and then went back outside. He made his way along the street opposite the running car until he was directly across from it. Running, Henne went across to the driver's side door, opened it and turned off the car. He then ran back to the barbershop to arm himself. As he went inside, Henne grabbed the first thing that he could find: an iron bar leaning in one corner. He probably figured that something was better than nothing and then went back out to face the robbers.

Tension was thick in the air. The vigilance committee knew that the robbers were in the bank right at that moment and that soon they would try to make their way to the getaway car. The money that they were stealing did not belong to them but, rather, to local men and women whom the committee knew. Families had invested that money in the hopes of building better lives for themselves and had worked hard for it. These would-be bank robbers would not take that away. The vigilance committee would stop them, even if it meant pulling the trigger.

Just about that time, Roy Purple came out of the bank door. As he did, the barber saw something that he did not like. It is very possible that he saw Elmer Moore behind his telephone pole several feet away. Whether out of fear, panic or some other reason that will never be known, Purple began firing his pistol as he moved toward the getaway car.

With those first four shots from Purple, the tension that had been so thick suddenly broke with all the ferocity of a thunderstorm. Return fire came from several vigilance committee members, pouring down a deadly rain of lead at Roy Purple.

The worst of that initial volley hit the barber full on. He fell to the sidewalk just a short distance away from the getaway car, dead. The black bag with all the money that Purple had felt was so important such a short time ago fell beside his lifeless body. The volley lessened a bit but still continued as Hamilton came running out of the bank next.

From his perch in the upstairs window, Al Klindt and Dick Tobin fired several shots. At first, Klindt had been firing a Colt .45 and was able to shoot Purple directly in the face with it. The blacksmith ran out of ammunition and quickly grabbed a .32 pistol from Dick Tobin to continue the assault.

As Hamilton rounded the car to get to the driver's side door, Archie Henne threw his iron bar at the man, striking him in the stomach. It did not even so much as slow the robber down, and Hamilton opened the door to climb inside. As Hamilton was getting into the car, Al Klindt hit him with his .32.

This bullet hole was placed in the side of the Stockman's Savings Bank (now Long Grove City Hall) during the robbery of 1921. *Author's collection.*

But Hamilton was tough. He kept firing his own pistol at his attackers. Two shots went through the window of a nearby pool hall, nearly hitting one of the men inside. By the time he closed his car door, Hamilton had been shot four times.

When it was apparent that Hamilton was not going anywhere in his car, thanks to the efforts of Henne, several locals rushed forward, guns in hand. They jerked open the car door and demanded to know where Hamilton had put his gun. Hamilton immediately told them that he did not have a gun, even though it was still in his hand. The vigilantes disarmed the robber and pulled him from the car. To make sure that the robbers could do no more harm that day, the locals handcuffed Hamilton and hogtied Roy Purple, despite the fact that it was obvious Purple was very, very dead.

The danger now past, the locals moved into the bank to check on the bank workers. Both Brownlie and Marti were a little worse for wear but were all right. By this time, the news of an actual robbery had spread around town, and several people came up to get a look at the scene. Curiously, they looked at the wounded Hamilton and the deceased Purple. They also took note of the various bullet holes in the bank and surrounding buildings.

Soon, the Scott County sheriff, William Brehmer, arrived with a complement of police officers. Word had been sent to them earlier, but it had taken the law enforcement officials some time to reach Long Grove. They were greeted by the vigilance committee members, many of whom had pistols still stuck in their waistbands or shotguns broken over one arm.

Brehmer greeted them in return and then went and examined the robbers. He immediately ordered that Hamilton, who was in a great deal of pain from his wounds, be taken into the nearby pool hall. He also ordered an ambulance be called for the man. For Purple, an undertaker was called to take his body away.

Inside the pool hall, Brehmer began to question Hamilton about the robbery as they waited for the ambulance. The robber would only say that someone had double-crossed him. When asked to elaborate or to identify his dead partner, Hamilton initially would not say a word. As time pressed on, however, he eventually admitted that he and Purple had planned the robbery. As far as being double-crossed, no one present understood what he was talking about, but it was thought at the time that Hamilton was referring to Purple.

Eventually, the ambulance and the undertaker came, and Hamilton and Purple were both returned to Davenport, although not the way either had intended. Reporters from the *Daily Times* and the *Davenport Democrat and Leader* came and spoke with the various people involved, including the vigilance committee members.

Later that afternoon, an acquaintance of Edith Purple was passing by the bulletin window of the *Daily Times* when she saw the announcement of Roy Purple's death. Stunned, she went into a nearby restaurant to call her old friend.

Called to the phone at her home, Edith was shocked to hear the news of Roy's demise. She knew that he liked to run with a bad crowd, but Edith had no idea that he had planned to rob a bank. She had begged him to stop associating with criminals and the like, but he would not listen. Roy Purple's flirtation with crime and wrongdoing had finally caught up with him.

The police began to investigate the crime right away. Witnesses had reported a gray car parked south of town close to the time of the robbery. Inside were a man, a woman and a baby. Possibly because of Hamilton's statement of being double-crossed, law enforcement thought that the car and its occupants might have had something to do with the robbery.

The next day, the county coroner, J.D. Cantwell, performed an inquest. Traveling to Long Grove, he interviewed many of the vigilance committee

members, as well as R.K. Brownlie and Jean Marti. The results were fairly cut and dried—Roy Purple had died from gunshot wounds received during the robbery.

Meanwhile, in Davenport, Harry Hamilton's life waxed and waned with each passing day. Admitted to Mercy Hospital after the robbery, Hamilton's condition was touch and go from the very beginning. At first, it seemed as if he was going to die at any moment. Then, he began to grow stronger, and the doctors started to become more positive about his recovery.

One day while Hamilton was recovering, a man tried to gain access to the bandit. A policeman, Jess Lowenthal, who had been ordered to stand watch over Hamilton, stopped the man. Lowenthal had strict orders not to allow access to the wounded bank robber, and he had never seen this visitor before.

At first, the visitor identified himself as Hamilton's brother. Upon further questioning by Lowenthal, the man said that he was not a relation but was still part of Hamilton's family. The conflicting stories raised a red flag with the policeman, and the visitor was ejected from the building.

Before long, Hamilton realized that he was dying. He contacted hospital authorities and asked that they summon a priest for him. When the clergyman

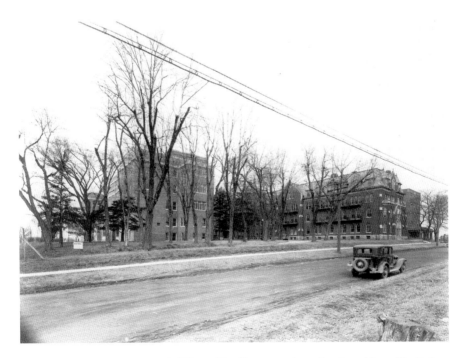

Mercy Hospital, where a wounded Harry Hamilton was taken after the robbery. He died here four days later. *Courtesy of Davenport Public Library.*

arrived, Hamilton asked him to please make sure that his wife received all of his worldly property.

On December 17, 1921, Hamilton died of his wounds at Mercy Hospital. Despite being in a great amount of pain, Hamilton maintained a positive attitude until the end, joking with his nurses and with Lowenthal.

William Brehmer's investigation into the gray car and any possible accomplices associated with Hamilton and Purple did not amount to anything. There was never any evidence to suggest otherwise. There was also no further investigation into the stranger who tried to gain access to Hamilton as he lay dying in Mercy Hospital. His identity would remain unknown.

The body of Roy Purple was held at the funeral home of Fred N. Ruhl until his parents came from Indiana to collect it. His widow, Edith, and their twin sons went back with Purple's family. After she buried her husband, Edith went to live with her father in Champaign, Illinois.

Hamilton and Purple had stolen around $5,000 from the Stockman's Savings Bank. Most of it was found in the black bag that fell beside Purple when he was shot and killed. By the next day, bank officials were still missing nearly $6. As they searched, they found all but ten cents of it. Try as they might, it could not be found.

As the officials thought about where it could be, M.H. Calderwood, who was one of the officials helping count the money, remembered something. On the night of the robbery, he and his son were in the bank when they both heard something hit the floor, roll across the floorboards and then drop into an air register. Everyone was satisfied that what they heard was the missing coin, and they considered all the funds stolen during the robbery accounted for.

The Iowa Banking Association had offered a $1,000 reward to vigilance committees that were able to successfully deter bank robberies and burglaries almost from the time it had come up with the idea of vigilance committees. After the Long Grove bank robbery, a meeting was held by the Scott County Bankers Association to discuss the events of the crime and what things could have been done better during the situation. Also to be discussed was how the reward would be distributed among the various parties involved.

Eventually, it was established how it would be distributed. Not only would the vigilance committee members be given a reward, but even the telephone operators who had placed calls to Eldridge and the police department would have a share. Half of the money would come from the Iowa Bankers Association and the other half from the Scott County Bankers Association.

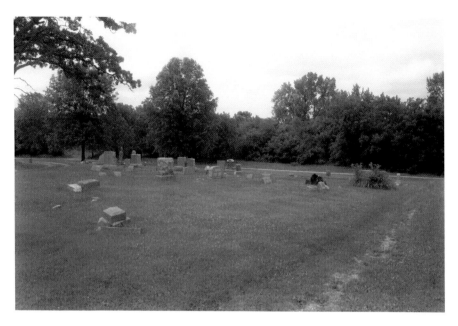

Harry Hamilton was buried in this section of Oakdale Cemetery in Davenport, Iowa, in an unmarked grave in 1921. *Author's collection.*

A funeral service was held for Harry Hamilton at Stapleton Funeral Home. The attendees were an odd group. They were old and young, quiet and loud. Hamilton had such a colorful background when he was alive that it should not really come as a surprise that such a diverse group would attend his funeral. After the services were over, his body was taken to Oakdale Cemetery in Davenport, Iowa, and buried in an unmarked grave.

And thus the life of Harry Hamilton came to an end. He started out well enough and then fell into a criminal lifestyle that he could never quite break free of. Eventually, it would cost Hamilton his life.

BIBLIOGRAPHY

Books

Atlas of Scott County, Iowa. Davenport, IA: M. Huebinger & Co., 1894.

Atlas of Scott County, Iowa. Davenport: Iowa Publishing Co., 1905.

Boyer, Clark, Jr., et al. *The Enduring Vision: A History of the American People.* Lexington, MA: D.C. Heath and Company.

Danbom, David. *Born in the Country: A History of Rural America.* Baltimore, MD: Johns Hopkins University Press, 1995.

Downer, Harry E. *History of Davenport and Scott County, Iowa.* Vol. 1. Chicago: S.J. Clarke Publishing Company, 1910.

————. *History of Davenport and Scott County, Iowa.* Vol. 2. Chicago: S.J. Clarke Publishing Company, 1910.

Hamer, Richard, and Roger Ruthhart. *Citadel of Sin: The John Looney Story.* Moline, IL: Moline Dispatch Publishing Company, 2007.

History of Scott County, Iowa. Chicago: Inter-State Publishing Co., 1882.

Kitchen, Martin. *The Cambridge Illustrated History of Germany.* Cambridge, UK: Cambridge University Press, 1996.

Preston, Howard H. *History of Banking in Iowa.* Iowa City: State Historical Society of Iowa, 1922.

Schipper, Kristen D. *Bettendorf: The First Century.* Bettendorf, IA: Heritage Subcommittee Bettendorf Centennial Committee, City of Bettendorf, 2003.

Schwieder, Dorothy. *Iowa: The Middle Land.* Ames: Iowa State University Press, 1996.

Scott County Heritage Book Committee. *Scott County Heritage*. Dallas, TX: Taylor Publishing Company, 1991.

Tweet, Roald D. *The Quad Cities: An American Mosaic*. Davenport, IA: Brandt Company, 1996.

Wilkie, Franc B. *Davenport Past and Present*. Davenport, IA: Publishing House of Luse, Lane & Co., 1858.

Government Documents

David, John. Coroner's inquest. Davenport Public Library, Davenport, IA.

Drentner, Harry. Coroner's inquest. Davenport Public Library, Davenport, IA.

Iowa Death Records. Davenport Public Library, Davenport, IA.

Iowa Divorce Packets. Davenport Public Library, Davenport, IA.

Iowa Marriage Records. Davenport Public Library, Davenport, IA.

Purple, Roy. Coroner's inquest. Davenport Public Library, Davenport, IA.

United States census records.

Online Sources

Allpar.com. "Hudson Motor Cars (with a Spotlight on the 1936 Hudson Cars)." www.allpar.com/cars/adopted/hudson-1936.html (accessed June 15, 2017).

Conwill, David. "Superlative Six—1929 Hudson Super Six." www.hemmings.com/magazine/hcc/2016/09/Superlative -Sic---1929-Hudson-Super-Six/375002.html (accessed June 15, 2017).

Davenport Public Library Special Collections Blog. "The Death of Colonel George Davenport." blogs.davenportlibrary.com/sc/2008/06/30/the-death-of-colonel-george-davenport (accessed August 15, 2017).

USPS. "Rural Free Delivery." About.usps.com/who-we-are/postal-history/rural-free-delivery.pdf.

Westholm, Woodrow W., and John Ruskin. "Postal History of Iowa." State Historical Society of Iowa. Ir.uiowa.edu/annals-of-iowa/vol32/iss7/6.

Newspapers

Daily Times
Davenport Democrat and Leader
Quad City Times

INDEX

S

Schleswig-Holstein 45
Schultz, Henry 18, 19, 20, 21, 22,
 23, 24, 25, 26, 27, 29
Schultz, Mary 18, 19, 20, 21, 22,
 23, 24, 25, 26, 27, 28, 29
Stockman's Savings Bank 85, 88,
 90, 95, 100
Summit Church 30, 35, 38, 40, 42

U

United States Postal Service 58

V

Valley City, Iowa 17

W

Washington, D.C. 18, 19, 20, 21,
 24, 29
Willer, Claus 47, 48, 49
Willer, Peter 90, 95

ABOUT THE AUTHOR

John Brassard Jr. is an author and historian from eastern Iowa. He has a degree in history from Iowa State University and is a history columnist for the *DeWitt Observer*. John's work has also been featured in the *North Scott Press*, the *Quad City Times*, the *Catholic Messenger* and *Iowa History Journal*. He serves as a board member and newsletter editor for the Scott County Historical Preservation Society and works with the Scott County Historical Society, the Central Community Historical Society and the Friends of Walnut Grove Pioneer Village. He lives in Bettendorf, Iowa, with his wife and children.

Visit us at
www.historypress.net